Platform for Art
Art on the Underground

black dog
publishing
london uk

Contents

D

Platform for Art
Art on the Underground

Preface
Tim O'Toole

London Underground (LU) is the lifeblood of London itself and as such plays an important cultural role in the life of the city. The organisation has taken this responsibility very seriously since the early twentieth century and its patronage has led to the creation of some of the great icons of British design and architecture.

Currently LU is undergoing one of the most challenging and exciting phases of its long history: the biggest programme of investment our organisation has ever seen that will result in the modernisation of the entire network. At this time we are also highly aware of our distinctive heritage, and Platform for Art continues the Tube's crucial relationship with art and culture as part of this process. With an impressive output of exhibitions by world-class artists over the past few years and an integral series of community projects that involve the participation of LU staff, customers and stakeholders, the programme has set a high standard. As the programme develops we will see more of these projects come to fruition and also some exciting new commissions that will have a more permanent presence in stations, continuing a tradition that led to such works as that by Eduardo Paolozzi at Tottenham Court Road station and that will leave a lasting legacy for the future.

This is an appropriate moment to look at what has been achieved by the Platform for Art programme. This book documents and celebrates the work of the programme beautifully whilst also serving as an opportunity to reflect with intrigue and excitement on what the future may hold. On this note, the title of this book is highly appropriate, combining the existing name of the programme with its new name "Art on the Underground", under which it will continue from November 2007.

I am delighted to be the chair of the advisory panel for the programme. Advocacy and serious evaluation of its work has been very much augmented by the gathering of members from LU, Transport for London and the Greater London Authority, as well as arts professionals. I am indebted to each member of the panel and the Mayor, Ken Livingstone, for their support.

I am grateful to Tamsin Dillon and the Platform for Art team; Anya Oliver, Sally Shaw and Cathy Woolley for their passion and commitment and for the hard work they continue to put into this programme. Previous team members are also acknowledged in this book along with many other London Underground staff and contractors whose work has been crucial in delivering the programme. I also would like to thank all the artists who have worked with us to produce such an astonishing range of high quality work.

We have worked in collaboration with many other organisations to commission and produce a range of art works and I would like to acknowledge that these works have made a significant contribution to the programme. Certain projects would not have been possible without the additional support of a number of other agencies including in particular the Arts Council England and Arts and Business. We hope that this support will continue as the programme develops and builds upon a rich legacy.

I am proud to lead an organisation with such a rich cultural heritage as London Underground and it is vital that this tradition continues through its art programme. I am committed to supporting the progress of this work for the future so that many more important works of art become part of London Underground through its commitment to art and design. The benefits to be gained for all concerned are especially important for the millions of people who travel with us and whose journeys each day are greatly enhanced by the addition of art works on the Tube.

Mark Titchner,
Art work panel for
I WE IT, 2004.
Gloucester Road station.
Image courtesy the artist.

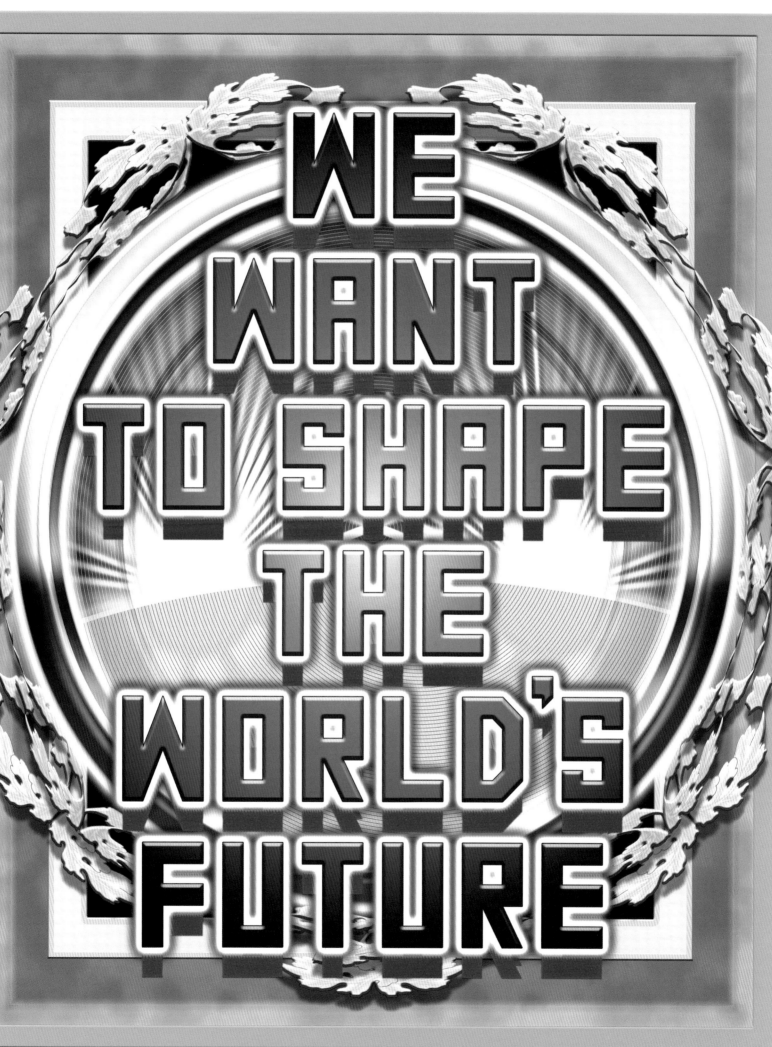

Introduction – Art and the Underground
Tamsin Dillon

Disused platforms, empty windows, the Tube map, trains, hoardings, empty walls, leaflets, advertising sites, Oyster card wallets, tannoy systems. These are all sites where Platform for Art has commissioned artists to present new works of art to be encountered by millions of people as they travel around London Underground (LU). LU is first and foremost a transport system; a web of tracks, stations and signals for trains to enable people to get around the city of London. Since the system began to grow in the latter part of the nineteenth century, LU has become a central part of London's infra-structure; it has played a crucial role in the development of the city and is such an intrinsic and essential part of it that the notion of one without the other is utterly inconceivable. Approximately 3.5 million journeys are taken every day on the Tube and this is set to rise to four million by 2020. As they travel, people move through an environment constructed over more than a century and may pass through stations built as many as 100 or as few as 10 years ago. They are continuously assailed by messages from spoken announcements to signs, information and advertising. On their journeys they cross each other's paths, travel in huge numbers at peak times, encounter strangers and meet friends. This unique setting is also a focus for artists who make art in response to a wide range of particularities within it. The artworks they create add another dimension to Tube travel and reveal new and unexpected perspectives on it.

Art on the Underground is not a new idea; LU has been one of London's most consistent public sector patrons of the arts, working with numerous artists, designers and craftspeople in every aspect of its architecture, poster design, train livery and upholstery fabrics, as well site specific art commissions in stations. London Underground's commitment to the arts and to excellent design is

the reason why the LU brand remains one of the most recognised in the world. The unique round logo announces its stations and information, the Johnston typeface is used for all written communication, Harry Beck's map simplifies the complex series of Tube lines for its users, and artworks commissioned for stations during the 1980s have become landmarks and exemplify LU's commitment to public art commissioning. These are all elements of a unique identity that is the envy of, and that has been emulated by, almost every urban railway system worldwide.

PFA has emerged only in 2000 (some 150 years after the first underground trains started to run) to build upon the firm foundation of LU's artistic heritage, and is a conduit through which new art is being produced to continue a contemporary cultural connection between LU and a wider context. With a vision to deliver a world class programme of contemporary art projects for the unique context of London Underground, PFA incorporates several distinct yet integrated areas of programming. Although these fit into two broad strands that produce contemporary art projects and community focussed art projects, they work as an integrated whole where projects frequently overlap. Contemporary art emcompasses a range of practices; artists make work in and for a wide range of contexts that includes the gallery but increasingly involves exploring the possibilities and opportunities in less conventional and public spaces. Recent discussions around art in these kinds of spaces, including art in the public realm, have drawn upon the history of public and community arts and more recently socially engaged practice. The move towards relational, situated and mediated art – recently coined as the "social turn" – takes the complexity of a site to include its history, its population and its function as well as its physical characteristics. Defined

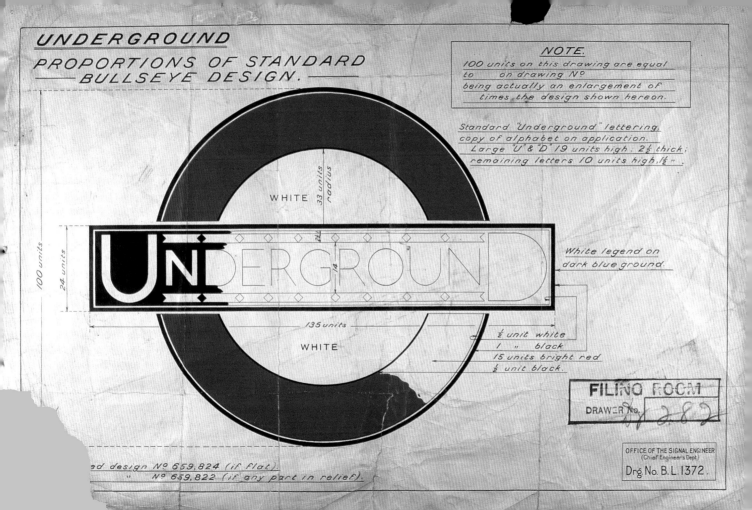

in this way a wide range of sites have become the starting point for making art across multiple disciplines. PFA sets out to engage with this arena and to work with the best artists from the UK and worldwide. It offers a unique opportunity that is integral to London Underground and contributes to the development of contemporary art in public space. Each project throws up a new set of challenges to negotiate in what is a sprawling, complex regulated space run by an exacting organisation. To date, this has led to a wealth of new temporary commissions across the network.

This book provides a record of a slection of the projects that Platform For Art has realised between 2002 to 2007. It tracks the development of the programme and reflects on its impact and its future direction. The challenges involved in producing art in such a complex environment are examined as are the incentives and benefits for LU in its continuing patronage of such work. Alex Coles maps out a history of art and design on the underground and analyses how Platform for Art takes it in a new direction. He makes a comparison with art historical precedents to contextualise the development of the PFA programme and considers in detail a range of the projects that have been realised.

In 2003 PFA presented a project by Cindy Sherman at Gloucester Road station that set a new pace and ambition for the programme. Ten enormous portraits of women in various colourful guises and curious poses set against a uniform grey background greeted Tube travellers and offered a new scene to contemplate as they waited for their trains. In response these people may have speculated who the women were and why they were portrayed on this large scale, or perhaps they simply considered them as an intriguing addition to their journey. With over a million people using the station every month, this audience was undoubtedly the largest and most diverse to view Sherman's work. This might be considered reason enough that any artist would want their work to be presented in such a situation. Yet the challenges and complexities of this public and highly controlled space make it at once a difficult, exciting and dynamic opportunity within which to develop and present art. Sherman's Gloucester Road billboard commission was an extension of her exhibition that ran concurrently at the Serpentine Gallery and was conceived and produced in collaboration with the Gallery. The dialogue with the artist and the Gallery and the public and media response to the project was key to the way PFA has gathered momentum and reputation. The site at Gloucester Road, a disused platform running the length of the station, calls for production of large-scale artwork in order to have an impact in the space. From consideration of the role of each work to its production the

Cindy Sherman,
Billboard Commission, 2003
Panel for the series
for Gloucester Road
Underground station.
Image courtesy of the artist

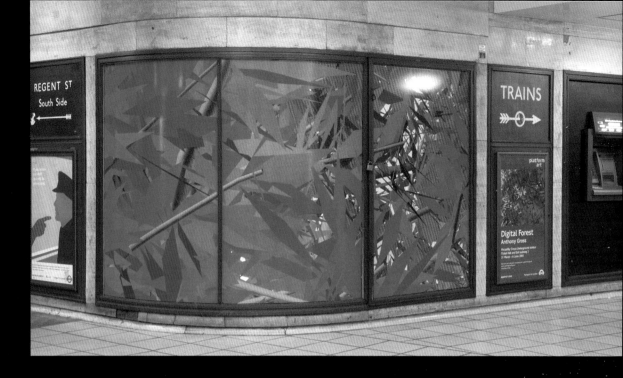

Anthony Gross,
Digital Forest, 2005.
Installation view,
Piccadilly Circus.
Image courtesy the artist
and London Underground.
Photo: Daisy Hutchison.

PFA team negotiate a complex set of issues where communication and flexibility are of crucial importance. From 2003 to 2005 a series of specially commissioned large-scale billboard images, made by an international range of artists, followed the Cindy Sherman project. It has been increasingly possible to take on more ambitious ideas and the following two projects, by Beatriz Milhazes in 2005 and Chiho Aoshima in 2006, were images that used the whole length of the platform. New processes for production become tried, tested and trusted by those in the network who regulate safety, security and content as an utmost priority. The site is now an annual commission and artists have more time to allow their ambitions to be realised. The Platform for Art programme has grown in scope and in ambition, working with some of the worlds leading artists and collaborating with other important organisations on the projects at Gloucester Road and elsewhere on the network.

Platform for Art has consistently conceived and strategically developed new sites for artistic production, making an impact not only at specific sites and stations but also across the whole London Underground network. At Piccadilly Circus station, a set of empty window frames in the ticket hall is a site where a range of artists' responses have arrested the attention of travellers passing through on their way to the trains. Anthony Gross used dramatically colourful imagery in his project *Digital Forest*, whilst Janette Parris' work, *Going South*, a set of posters of a fictional band, focussed on the proximity of the famous music store Tower Records. Asia Alfasi used the site quite differently, offering a cartoon narrative about travelling on the Tube – *The Non-savvy Non-commuter*. These projects use one station as a site to present new artworks but several PFA initiatives bring mass-produced images into many places at one time, utilising the network itself for distribution. The front cover of

the Tube map has become an important site for exploiting this opportunity. PFA has established an ongoing series of commissions that celebrates the work of established, high profile UK based artists by inviting them to make a work in response to the Tube map. Their artworks are reproduced for the cover of the pocket version of the map, 15 million copies of which are produced annually and are available free from every station. David Shrigley's work for this site was an image of all the Tube lines scrambled into a ball – emphasising the clarity of the map itself when the user opened the map up. A further initiative for distribution in the network places specially commissioned posters into advertising sites. Artists making work for this series have sometimes subverted the opportunity by adopting the language of advertising itself to inform viewers about work they are showing elsewhere. Lucy Skaer's project for this series led to the production of posters displaying a web site address for her collaborative project *Tatlin's Tower*. A series of posters called *Go to the Gallery* was an important collaboration for PFA, raising its profile by placing art across the network. Working with 30 London-based galleries and art organisations

the result was a collection of over 35 posters, featuring reproductions of artists' images.

The London Underground network is the setting and context for PFA and its history and development indirectly informs certain projects. The centenary of the Piccadilly line led to a major new initiative, *Thin Cities*, for which emerging and internationally-renowned artists were commissioned to make works at sites along the line throughout the centenary year. This ambitious project was conceived to be realised at a large scale that demanded input from a temporarily extended PFA team. Independent curator Gavin Wade was invited to work as part of the PFA team that ultimately devised and delivered the project. The starting point of Italo Calvino's book *Invisible Cities*, was adopted to form a coherent theme for the project and over 20 new artworks were commissioned and presented on the Piccadilly line during 2007.

The approaches outlined here have been developed to build up a range of strategies and an inventory of projects and artworks for LU whilst also building a strong profile for PFA. The curatorial approach to the programme also reflects the continuing development of contemporary art practice and the different ways artists make work and this extends to addressing notions of where art is produced and by whom, particularly through community focussed projects. Through this area of programming, PFA projects work to strengthen links with staff and stakeholders. Artists are commissioned to developed projects that directly engage with LU staff and communities based locally to specific stations. A project that celebrated the Circle line, *From Here to Here*, brought together LU staff, art students and writers to create a unique poster and a book of short stories for every station on the line. PFA's

David Shrigley.
Map of the London Underground. 2006
Artwork for the February 2006 Tube map cover.
© London Underground.

community focussed projects take a range of formats and engage a wide diversity of people. All those involved participate in the production of art works that are subsequently presented as part of the programme. The artist Gayle Chong Kwan exhibited her work at Southwark station at the start of a six month residency where she worked with LU staff, students and local market traders to produce three new art works based on themes arising from her original work. The new works were placed at London Bridge and Southwark stations and celebrated through events that engaged all the people involved. The project helped to develop important new relationships within the organisation as well as building a sense of trust and ownership for those who live and work in the area. Customers are encouraged to engage with the programme in many ways such as through opportunities to attend artist talks and events and also by responding to projects by sending their comments about projects to the Platform for Art website for publication. Through these initiatives, a revived sense of ownership of LU has become established for those involved and over time, these new relationships also help to strengthen advocacy for art on the Underground.

For Platform for Art collaboration has been a strategic objective that is exemplified in the community projects and has ensured London's

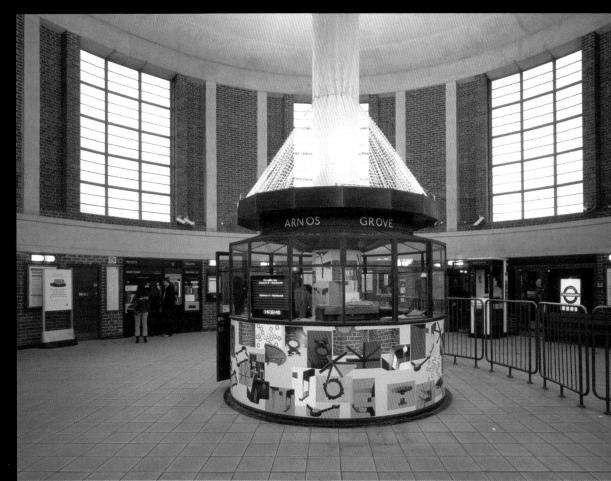

Simon & Tom Bloor.
The necessity of everyday living, 2007.
Installation view,
Arnos Grove station.
Image courtesy the artist
and London Underground
Photo: Declan O'Neil.

cultural map is firmly rooted in the programme. Partnerships are central to the success of many projects and this way of working allows for the creation of complex new works that would not otherwise be possible. From 2003 to 2005, a partnership with Frieze Projects took place over the first three years of the Frieze Art Fair, leading to new works produced by Liam Gillick, Emma Kay and Richard Wentworth. In 2005 a significant new work in two parts by Muntean/Rosenblum was created for presentation at Gloucester Road station and at Tate Britain. In 2006, the San Francisco-based artist Bill Fontana used recordings of the Millennium Bridge to create a new sound work that was played simultaneously in Southwark Tube station and the Turbine Hall of Tate Modern. These projects, conceived and realised in collaboration with partners, offer artists a broader arena in which to make and present work and reach new audiences.

This consideration of some of the projects and strategies that are integral to Platform for Art serve to reflect how broadly its goals and objectives are pitched so that a truly integrated approach within the London Underground network can be achieved. Technically, the Underground is a complex environment in which to create and present art works. The small team responsible for every aspect of delivery needs to possess a crucial combination of skills, experience, enthusiasm and determination. The development of the programme and the approach to each individual project is underpinned by an understanding of how contemporary art has evolved to engage with such a context. The location of art outside the gallery leads to a reconsideration of the parameters that define it; new possibilities for thinking about the relationship between art and the architecture and broader particularities of other contexts are opened up. Platform for Art exists to ensure

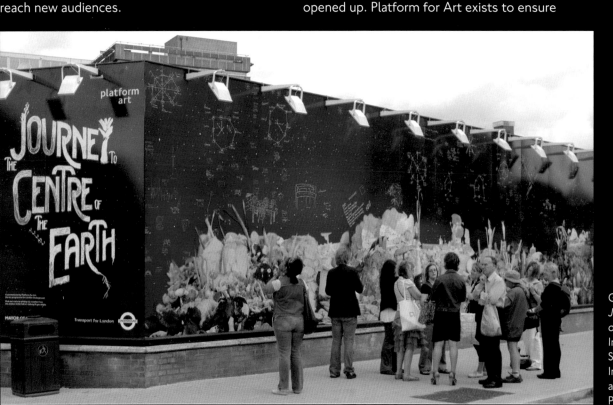

Gayle Chong Kwan,
Journey to the Centre of the Earth, 2007.
Installation view,
Southwark station.
Image courtesy the artist
and London Underground
Photo: Daisy Hutchison.

that art and culture remain central to the core values of London Underground and the curatorial strategies it adopts aim to ensure a continued critical engagement with contemporary art. The focus of PFA has always been the development and production of temporary artworks and this book is illustrated with a range of these projects. The continual changing and reinvention of sites allows the programme to reflect new approaches to making art and engages with the dynamic daily life of the network and of the city. The future will see permanent projects realised in stations alongside the continuing programme of temporary exhibitions. These permanent art works will be developed as an integral part of London Underground's modernisation programme and will sustain an important cultural element within that process.

Through Platform for Art artists continue to have an influence on the landscape of the Underground network, contributing to the development of its distinctive cultural identity, improving the quality of journeys and engaging its passengers to establish a strong sense of shared ownership. The process of producing new permanent art works will share the same ideals for excellence and reflection of contemporary art that inform temporary projects. The difference will be in the establishment of new landmarks that punctuate and enhance the journeys of millions of people. These distinct areas of programming serve to achieve the same broad aims, to bring great art to London's travelling public and to make significant contributions to London's cultural assets for an enduring legacy.

A PLATFORM FOR
SITE-SPECIFICITY

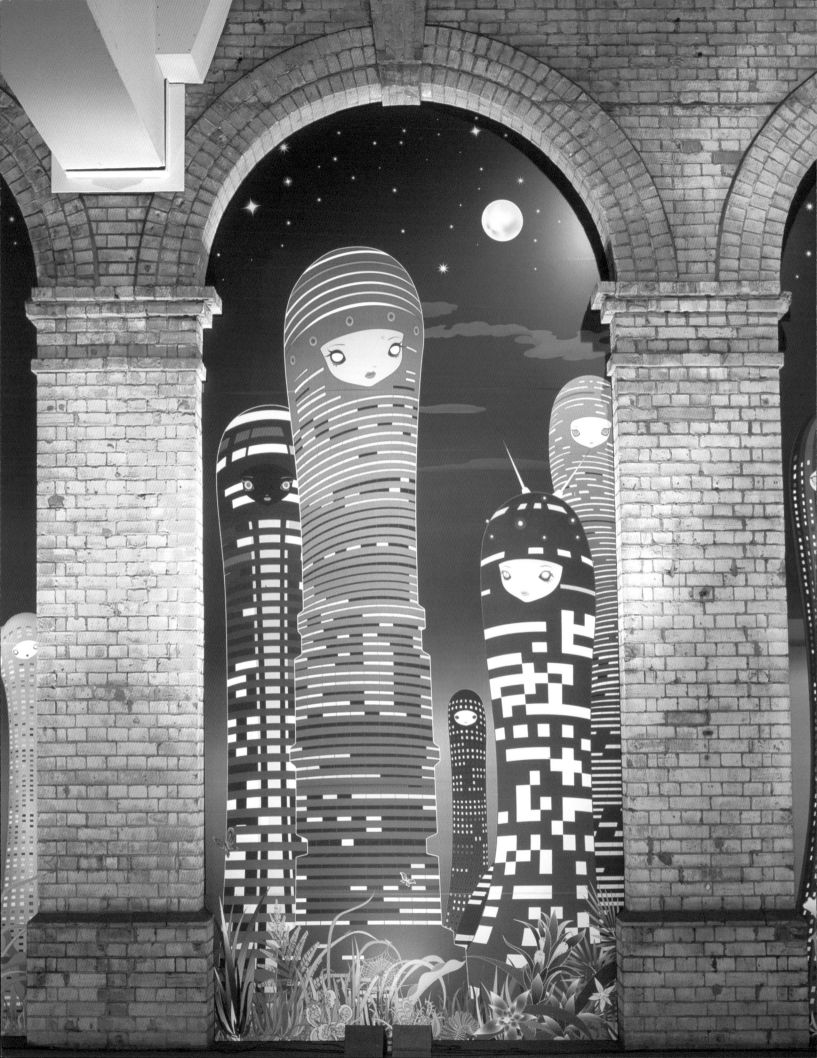

Introduction

Imagine you are standing on a Tube platform; instead of the dulled colours of the interior of the Tube station, there is a bright image depicting a multi-coloured landscape. But this landscape seems to be from another world, a future world perhaps, as depicted in a fictional comic-like language. Bright colours twinkle in the windows of the vertiginous towers populating the landscape; the sky moves through a spectrum of colours – from deep purple to a glowing orange – as it sets behind the towers. In every way, the work is carefully aligned to the level of the platform. Towards the top of the image, the towers depicted in the landscape appear to peak through the brick arches that support the ceiling of the station. This too makes the entire exterior scene appear continuous with the interior of the Tube station you are standing in. Until the moment when a Tube train comes into view and the work falls into relief behind it.

This imagined scene is depicted in an artwork by Chiho Aoshima inspired by Japanese Manga comics and is one project in Platform for Art's (PFA) large programme that encompasses a wide range of artists, sites and curatorial approaches to locating art on London Underground's (LU) network. A crucial element of the programme has been its attempt to reflect both the plurality of contemporary art and the diversity of the LU network by mapping the one onto the other.

The PFA programme has two distinct areas of activity: the contemporary and the community projects. Both of these are an integrated part of the same programme; where the former addresses artistic practice in relation to a given site, the latter endeavours to engage audiences directly in creative production. The series of commissions at Gloucester Road station are the flagship for the contemporary programme. Besides Aoshima's project, this includes significant new works by David Batchelor, Brian Griffiths, Beatriz Milhazes, Cindy Sherman and Mark Titchner. Piccadilly Circus station is residence to a similar ongoing series, with works by Simon Bedwell, Lothar Götz, Henna Nadeem and Janette Parris amongst others. There have also been a number of network wide initiatives: Tube map cover designs, which involve artists intuitively responding to the Tube map with their own design for its cover; poster commissions, where a range of sites including advertising space on the network is occupied by a poster design; the Go to the Gallery series, which links a PFA project with key London galleries by way of a poster commission by artists they are exhibiting; and the Piccadilly line based *Thin Cities*, a series of works commissioned to celebrate the centenary of the line. The community projects respond to the histories and particularities of individual sites by involving customers, local community groups and LU staff

Chiho Aoshima,
City Glow, Mountain Whisper, 2006.
Installation view at Gloucester Road station.
Image courtesy the artist,
Galerie Emmanuel Perrotin,
Paris/Blum & Poe, Los Angeles.
© 2006 Chiho Aoshima/
Kaikai Kiki Co., Ltd.
All rights reserved.
Photo: Daisy Hutchison.

in the very production of visual material, and they include *Platform Portraits* and *A Station Musical for Stratford*.

Despite its heterogeneity, each of the projects within the PFA programme can be interpreted as nurturing a contemporary response in the form of participatory and relational approaches to the notion of what is historically termed site-specific art. In order to comprehend these contemporary methodologies it is important to first grasp the key elements historically associated with site-specific art. A site-specific artwork is deemed to be an artist's response to their engagement with a particular site with the presumption being that if the site were different then so would be the work. One of the key post-war artists to produce site-specific works of art was Robert Smithson. What is so crucial about Smithson is that his site-specific works announce many of the key themes pertaining to site-specific art today. Indeed, such was the degree of Smithson's tenacity he oftentimes managed to commingle formal, poetic and political responses to a site together. A good example of precisely how Smithson did this comes with his *Partially Buried Wood Shed*, from 1970. Invited by Kent State University to produce a site-specific work, Smithson opted to use a dishevelled woodshed which was hidden away on the corner of the college's grounds. Onto this he tipped cartloads of earth until its central beam cracked and the roof started to cave in. The formal decomposition of the shed generated the poetic state of what Smithson referred to as entropy. Smithson's notion of site-specificity was dissident in nature with the aim of levying a critique of the gallery system.

Robert Smithson,
Partially Buried Woodshed,
1970.
Kent State University,
Kent, Ohio, USA.
Estate of Robert Smithson
Courtesy James Cohan
Gallery, New York.
© Estate of Robert
Smithson/licensed by
VAGA New York.

The notion of site-specificity has been moved on substantially since Smithson's era. Contemporary critics who have laboured to develop the history of site-specificity have been eager to emphasise the way site-specific art has maintained its contemporaneity by incorporating new ideas and approaches. James Meyer, one of the most innovative amongst these critics, has accurately conjectured that now there are two different notions of site: the 'literal' and the 'functional'.[1] In Meyer's terms, the literal site refers to a type of work that is literally located in one particular place. An example of this would be any of the projects PFA commissioned from Griffiths, Milhazes or Aoshima, since they are rooted to the site. The notion of the functional site that Meyer coined implies something that is much more expansive. This type of site-specific work involves an artwork that is no longer static because the artwork is now embedded within the working parts of an existing structure with a particular purpose. The consequences of the notion of the functional site for the PFA programme are obvious when considering the Tube map cover designs which, because they are fed into the existing literature available in all LU stations, become a crucial part of the way the service is perceived and therefore used. These cover designs only make sense in relation to their functional context, in turn having implications for the way the work is experienced since they work to entice the audience to pick up the map on account of the artist's response to it on the cover. The notion of the literal site often involves a form of passive optical contemplation of a composition as the viewer stands and regards the artwork, albeit perhaps in a fleeting way. The notion of the functional site necessitates a quite different form of contemplation which is often tactile in character. With the Tube map cover designs, the viewer – or user, as they should rightly be called given the nature of the interaction – has a more active, hands on, relationship with the work. Where one type of artwork is purely seen, the other is seen first and then touched and taken away.

Artworks that adopt the premise of the functional site often strive to include the viewer in the aesthetic make-up of the work. Within the discourse pertaining to contemporary art these are usually termed 'relational' works of art, after the French theorist Nicolas Bourriaud who coined the term "relational aesthetics" in the mid-1990s. Relational art, Bourriaud conjectured in his book devoted to the subject, is a "set of artistic practices which take as their theoretical and practical point of departure the whole of human relations and their social context, rather than an independent and private space".[2] The implications for this form of art for the PFA programme are not insignificant as first and foremost it is a programme set in the public domain.

With the communities programme, which is premised on involving a specific community in the production of the work of art, this becomes particularly pronounced. In his book, Bourriaud goes on to clarify how relational artworks are premised on "the basis of the inter-human relations which they represent, produce or prompt".[3] Bourriaud finds a fitting example of a contemporary artwork that manages to bring together all of the key aspects of site-specific work in Gabriel Orozco's hammock which the artist slung between two trees in MoMA's garden in New York in 1993. Orozco's work was site-specific as it was specially generated for the site so that it responded to the history of what the garden at MoMA was used for, namely, static modernist sculptures and a small cafe area with modernist chairs and tables. The work was relational since the hammock invited the viewer to become a user; once lying supine in the hammock the user caused a point of tension with the sculptures in view of how this interactive element contrasted so sharply with their modernist autonomy. Together with artists such as Felix Gonzalez-Torres, Orozco played an important role in the paradigm shift that occurred in the early 1990s towards a contemporary notion of relational site-specificity. In 2004 Orozco actually completed a project for PFA's poster commission series in conjunction with his exhibition at the Serpentine Gallery.

As part of their actual site-specificity, the PFA projects become a part of the everyday for the viewer. Rather than receive rapt attention, PFA commissioned works are often experienced while the viewer is notionally engaging in another activity, namely, travel. Each of the projects deals with this concept of the everyday in a different way – some seek to distract the viewer from their central activity of travel while others actually engage in this activity whether in a thematic or a functional way. For example, where the Tube map cover designs engage in the functional aspects of travel, Aoshima's installation portrays it as a subject. Brian Griffiths' sculpture *Life is a Laugh* at Gloucester Road distracts from the viewers diurnal ritual of travel through its sheer scale and idiosyncratic humour even though the subject of the work itself is the everyday.

PFA projects actively engage and compete with the other visual material on offer in the Underground network, which consists of the design of the stations, LU literature and advertising (a crucial form of secondary revenue for LU). The projects form a social bond with the viewer, in turn necessitating the development and deployment of strategies that are often contrasting and sometimes even antagonistic to the environment (the advertising in particular). The artworks produced operate in opposition to advertising's very principles which are premised on 'closing' on the viewer with a view to selling

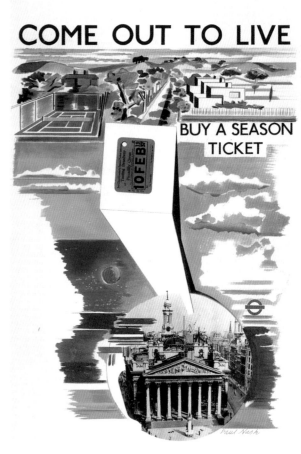

Paul Nash,
Come out to live, 1936.
Poster design for
London Transport.
© TfL/London
Transport Museum.

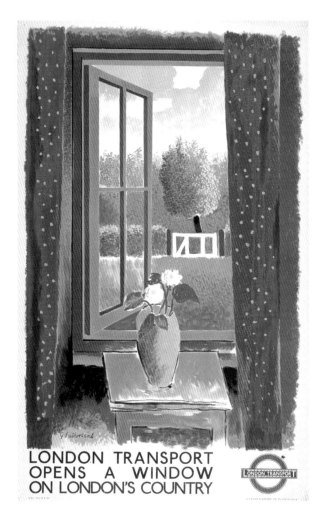

a product or service rather than opening up a dialogue with them. Instead of reducing communications to controlled areas of activity with specific and often preconceived outcomes, the PFA programme strives to establish fresh and unusual connections between producers and receivers. Artists have responded to this advertising in different ways. For *Shop Local*, an exhibition by Bob and Roberta Smith at Peer Gallery in East London, the artist consulted with a number of sole traders from London's East End in order to fashion a series of advertisements for them, aping the style of those advertisements painted on walls in Shoreditch in the early twentieth century when the sole trader was the norm. One of these artworks, promoting Ron's Eel and Shellfish stall, was reproduced through PFA as a set of posters that appeared in sites across the Underground network. Their lack of a slick veneer sharply differentiated them from the other advertisements in the stations in which they appeared and so invited a different response.

A further crucial context for the PFA programme is, of course, provided by the considerable history of artworks on LU. In fact, the history of LU's programme, piloted by Frank Pick, who was head of LU in the 1910s and 1920s and the newly formed London Transport in the 1930s, is underpinned by a conviction to reach beyond the confines of fine art and into the realm of design to create an interconnected visual experience for the viewer. Pick's programme was initially confined to the graphic elements of LU, particularly the signage, until the 1920s when he began employing artists such as Edward McKnight Kauffer and then, later, Man Ray, Paul Nash and Graham Sutherland to design posters, graphic designers like Edward Johnston to style the company's typeface, and architects including Charles Holden to design the actual stations.[4] The result was a seamless visual identity, often referred to by the avant-garde as "total design". In a letter to Holden, Pick noted his concern for total design and how it can only be achieved by factoring in all future requirements the stations may have into their design, thus necessitating a new form of design for public spaces:

> There is one matter which, one day, will come up for solution, the exhibition of posters upon the [station's] outside, and while it is not the intention to put posters upon the outside of this station at this time, we should have in mind that some day they will appear.[5]

Pick's work is indeed an important precursor to the present PFA programme, but the history of site-specific art with its contemporary relational dimension is also crucial. (The fact that a number of the projects engage with LU's design history is interesting since design is nothing if not site-specific as it

Graham Sutherland,
London Transport opens a window on London's country, 1933.
Poster design for
London Transport.
© TfL/London
Transport Museum.

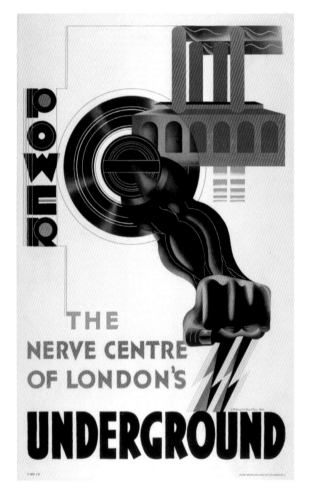

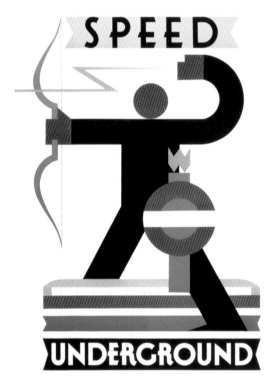

responds to a specific brief intended for a specific purpose.) Given this, it is appropriate that PFA's curatorial strategy dovetails elements from Pick's approach to commissioning art on the underground with a contemporary approach towards the notion of site-specificity. Where Pick was interested in what is often termed "design management" the PFA programme engages with the contemporary notion of curating.

Tamsin Dillon, Head of Platform for Art describes the curatorial strategy underpinning the programme:

> Through Platform for Art, artists are invited to make a response to a highly complex and layered environment, making new work that engages with a vast range of people, many of whom may be new to experiencing art. With a long term aim to reflect the multiplicity of contemporary art practise, we support emerging practises and celebrate the work of established artists. We

Edward McKnight Kauffer,
Power, 1931.
Poster design for
London Transport.
© TfL/London
Transport Museum.

Alan Rogers,
Speed, 1930.
Poster design for
London Transport.
© TfL/London
Transport Museum.

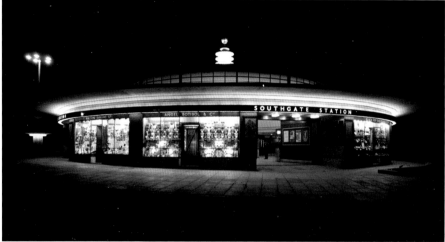

LONDON TRANSPORT—

want to contribute to ongoing debates around where art can be located and what it can be, encouraging our audience to reconsider the arena in which they are travelling and to find that a refreshing or intriguing experience.

The global context for PFA involves many art institutions commissioning artworks in the public realm and also numerous other transport networks that have an active art programme. For the energy and acumen behind Pick's original idea has influenced a host of other travel networks to produce their own art programme. By now this includes: Lisbon, Montréal, Munich, Naples, New York, São Paulo, Singapore, Stockholm and Tehran. Unlike LU's, most of the art projects commissioned for these spaces are permanent, though a number of them, such as New York's, do operate a revolving programme in coordination with the permanent one. As people travel more and the same artists are invited to respond to networks in different cities this global context becomes all the more important.

The issues pertaining to the artworks on the Underground commissioned by LU are turned to in the chapters that follow. The first chapter focuses on the Gloucester Road series, examining the works of Aoshima, Batchelor, Milhazes, Titchner and Griffiths. Chapter Two is devoted to the series at Piccadilly Circus, analysing the works of Lothar Götz and Henna Nadeem, followed by the *Thin Cities* programme. The third chapter looks at the various Tube map cover designs by Jeremy Deller, Liam Gillick, Emma Kay, Yinka Shonibare and David Shrigley. Chapter Four then deals with the communities programme, focusing on *A Station Musical for Stratford*, Suki Dhanda's Chinese Zodiac *Year of the Dog* project, and the *Platform Portraits*.

Man Ray,
*London Transport Keeps
London Going*, 1939.
Poster design for
London Transport.
© TfL/London
Transport Museum

Charles Holden's
Southgate station.
Image courtesy of the
London Transport Museum.
© TfL/London
Transport Museum.

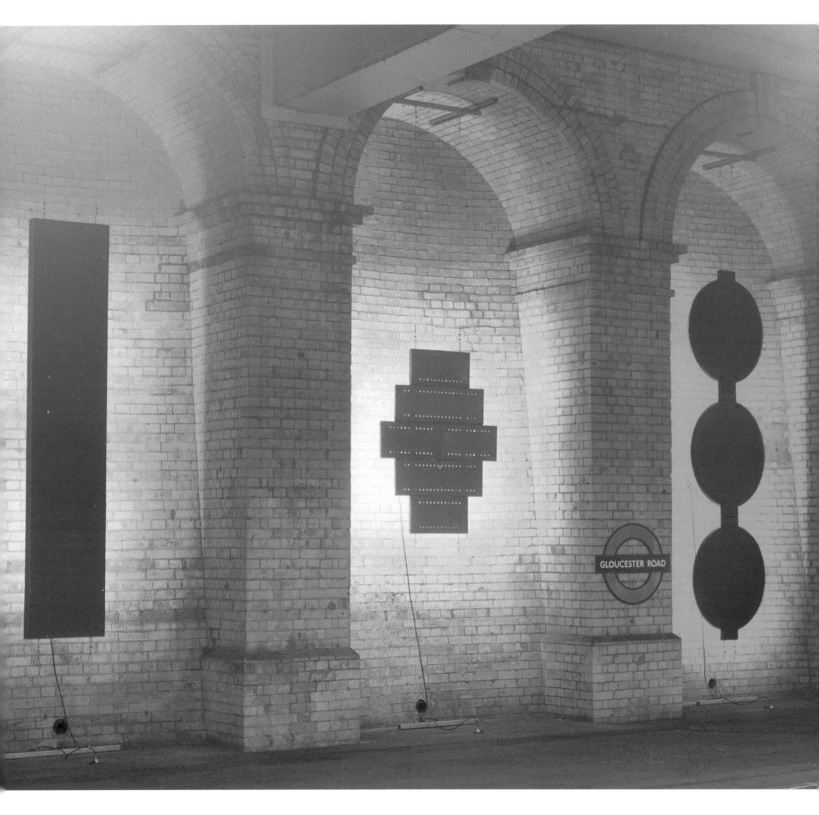

Chapter One

The site at Gloucester Road is located on the far side of the station on a disused District and Circle line platform. The 19 large brick arches that span the wall adjacent to the platform evenly paginate the space. Unlike many of the other sites selected for PFA projects, this one is at a relatively long distance away from the viewer and is never actually traversed by them. Consequently, the commissioned projects have to not only compete with the design of the station and its literature and advertising, but also their relative distance from the viewer. The artists commissioned have developed a number of strategies to deal with this – the deployment of colour being one of them. David Batchelor, Beatriz Milhazes and Chiho Aoshima all use colour both as a site-specific and an issue specific device with a keen awareness of how colour is a crucial part of the way different cultures articulate their place and presence within the fabric of a city.

Batchelor's contribution to the Gloucester Road series is descriptively titled *Ten Silhouettes*. While the output of the Minimalist artists to which Batchelor's work may first seem to refer in its formal make-up are now sitting comfortably in the precious environs of the museum, Batchelor's sculptures refer to the city – its streets and scrapyards – while also being firmly located in a Tube station within it. Batchelor channels the pulse of urban existence through the tired limbs of Minimalism in the form of rays of quotidian colour.

Ten Silhouettes is constituted from a series of ten structures hung in the arches that span the site. Each structure is fabricated from found steel or aluminium, centrally suspended, and back lit. A number of the structures are actually fabricated using items that have been decommissioned from the Underground network and would have otherwise gone to the scrapheap. The structures present a conundrum: despite being raw and clunky, the way they are back-lit means that the glow emanating from each one works to distract from their materiality; the softness of the light dissolves the hardness of the metal. The colours are analogical in nature – a deep purple, an acidic yellow and a buzzing red – and in so being reflect certain types of colours found in the city. These colours come from a variety of sources, whether they be found in neon signage, car bonnets or even in Tube signage.

While the colours emanating from Batchelor's structures appear to be generic in nature – that is to say, they do not refer to a specific paradigm of colour within the city but rather a general sense of synthetic colour found throughout it – the site is specific. This creates a further conundrum between the work's reference system and the actual real site in which it is located. Milhazes' *Peace and Love* utilises certain elements familiar to Batchelor's

David Batchelor,
Ten Silhouettes, 2005.
Detail of installation at
Gloucester Road.
Image courtesy the artist
and London Underground.
Photo: Daisy Hutchison.

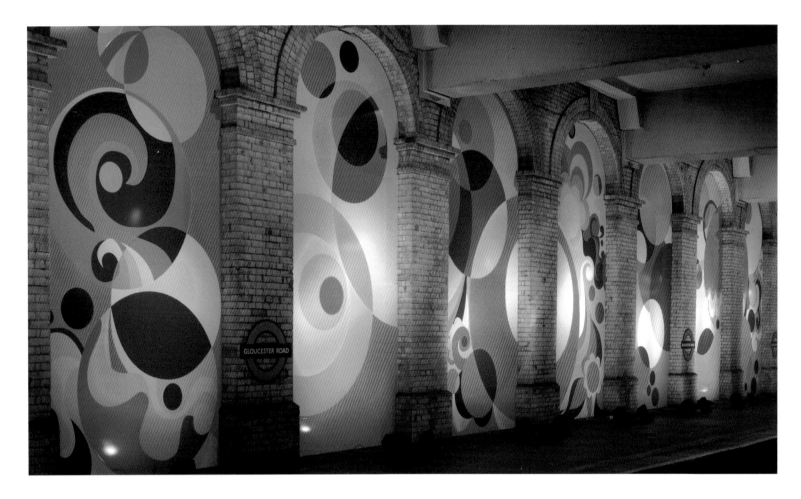

sculptures to energise the very same site but steers them in a completely
different direction. Where the colour in Batchelor's back-lit work is relatively
ambient and subdued since it spills out from behind, Milhazes' colour
addresses the viewer head-on – it is, literally, front-lit. The swirls and curls
of the configurations on the panels spanning each of the 19 vaulted arches
all intersect, forging a seemingly continuous pattern that jumps forward
and dances in front of the eye. Where Batchelor's structures are static and
contained within each of the arches, Milhazes' configurations flow between
them, a quality Milhazes is highly aware of:

> My project is connected to the motion in a subway station…. What I kept
> in mind with this project was how it could work as a possible 'animation'
> of a sequence of images. An interaction with the public while they were
> in motion seeing from inside the train, while they were waiting, leaving or
> arriving at the station. A very short moment of living with the pictures. No
> contemplations.

Beatrice Milhazes,
Peace and Love, 2006.
Detail of installation at
Gloucester Road.
Image courtesy the artist
and London Underground.
Photo: Daisy Hutchison.

The luscious deep purples and bronzed ochres in *Peace and Love* serve to kick forward the lemon yellows and pale pinks. These colours are not those of a Western city but of a Brazilian city such as Rio de Janeiro. The dancing forms are carnivalesque in appearance and are precisely what serve to move the colours around the panels. Each of the panels is densely packed with references from high and low origins, both contemporary and historical: Brazilian Baroque imagery, Sixties piece signs, carnival decorations, jewelry, embroidery and lace all vie for attention on these tightly packed surfaces.

Milhazes' paintings generally translate the specific characteristics of the site in which their compositions are configured (usually her studio in Rio de Janeiro) into a general vocabulary, which is then deployed across a surface. With *Peace and Love*, a further step in the translation process has been taken as this general language was edited down for the site. The process of editing and the translation from the specific to the general – and back to the specific again – means that her vocabulary moves through three stages: the original one of the raw material in the Brazilian city, through to the studio in the form of the paintings, and onto the site at Gloucester Road. As a result of injecting elements of colour from the vernacular of her own city – then recontextualised in London – Milhazes' colours appear to be anything but quotidian. This veritable mapping process in turn leads to the production of a space – the Brazilian city – within a space in the city of London.

Aoshima's *City Glow, Mountain Whisper* is also suffused with non-Western pictorial elements articulated through colour but also pictorial imagery. Like Milhazes, Aoshima is fascinated by the way her work relates to the movement of the train. The result of this interest is a composition that can be perceived both fleetingly and when standing stationary on the platform, either from the nearest platform to the work, which tends to result in the viewer being enveloped, or from the platform further back, where the entire composition can be more easily perceived as a whole. Add to this the way *City Glow, Mountain Whisper* was often seen in passing by the passenger and you have a complex perceptual situation where the address of the work operates on numerous perceptual levels. Regarding this, together with the precise architectural scenario presented by the site, Aoshima comments:

Beatrice Milhazes,
Peace and Love, 2006.
Full schematic for installation
at Gloucester Road.
Image courtesy the artist.

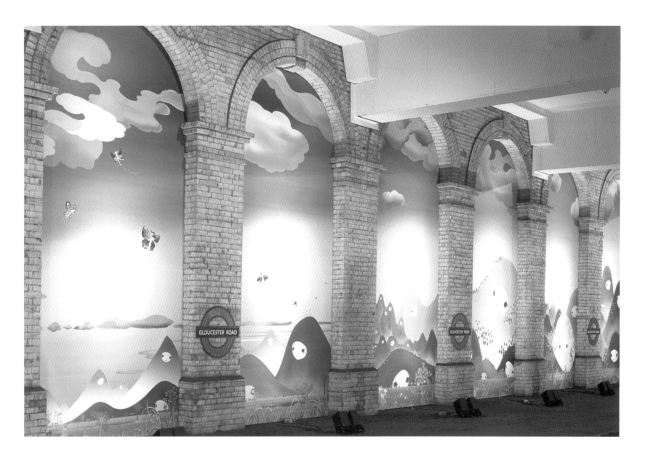

I thought of the place [the works] would be installed, the shape of the arches, the flow of people coming in and out of the station, riding the trains, and from all of this, the final image came into my head. I was very inspired by the shape and material of the arches, and… seeing the work installed… in the beautiful old brick and stone setting.

City Glow, Mountain Whisper is a layered image which operates from foreground to background and from one end to the other. The foreground is packed with foliage, the middle ground with the drooping towers and the background a serene sky. As the depicted scene moves from day to night, and from an urban to a rural scene, the towers are replaced by hills and the inky sky by a paler purple one. The passenger's journey is hereby reflected in the work as the colours and the composition change.

Mark Titchner and Brian Griffiths have both adopted very different responses to the Gloucester Road site to those discussed thus far. Titchner mobilises a seemingly decorative formal vocabulary and uses it as a backdrop for a series of assertive slogans set on panels. Regarding his contribution to the

Chiho Aoshima,
City Glow, Mountain Whisper, 2006.
Installation view at Gloucester Road.
Image courtesy the artist, Galerie Emmanuel Perrotin, Paris/Blum & Poe, Los Angeles.
© 2006 Chiho Aoshima/ Kaikai Kiki Co., Ltd.
All rights reserved.
Photo: Daisy Hutchison.

Gloucester Road site Titchner comments: "I wanted to make a work that was specific to the site with its proximity to advertising. A work that was to be located in the context to which it refers." The phrases making up the slogans structuring the work were poached from the so-called corporate vision of each of the worlds top ten brands as they were published in a randomly selected week on the Global Brand Scoreboard, each one of them combined with the prefix "We Want", a phrase appropriated from the five point plan of the anti-capitalist revolutionary group The Black Panthers. A selection of the slogans read: "We Want to Nurture and Protect"; "We Want What We Never Thought Possible"; "We Want to Shape the World's Future". The prefix turns each of these phrases, which otherwise might sound harmless, into something bordering on a threat.

The decorativeness of the backdrops that Titchner designed for the slogans purposefully works against the aggressive assertions made in each of the texts. One of the reasons the backdrops appear so at odds with the text is because of the way they recall the designs of Willliam Morris, albeit by way of the psychedelic poster and album cover designers of Sixties rock bands, such as the 13th Floor Elevators. Morris' decorative work was itself borne out of a politically motivated Utopian quest for the arts to unite and to become a part of everyday life. So both the text Titchner uses and the decorative backgrounds teem with references. The texts are particularly complex since they have a double meaning: in one reading they refer to capitalist ways of trafficking information and in another they refer to anti-capitalist sources. Titchner has opted not just to lay the text on top of the patterns but to push the situation further and create a dynamic relationship between them: in some of the panels the slogans appear to start to recede into the backgrounds, so complex is their interplay in the relatively flat space they operate in, and on these occasions the work has a very different resonance to when the texts are quickly legible.

For the slogans, Titchner appropriately uses aggressive reds and bold whites, in one instance set off by a cheap 3-D effect in lurid green that serves to make the text jump out at the viewer. More than any of the other projects at Gloucester Road, Titchner's directly responds to the visual competition present in the Tube station, the advertisements in particular. Each of Titchner's bold billboards stands out against the posters placed around the Tube advertising services and products. In this sense, they assert a strategic critique of the way the concerns of large corporations are often subliminally pressed on the public. Indeed, Titchner's billboards make explicit the strategies implicit to advertising by rendering them overblown, ugly even.

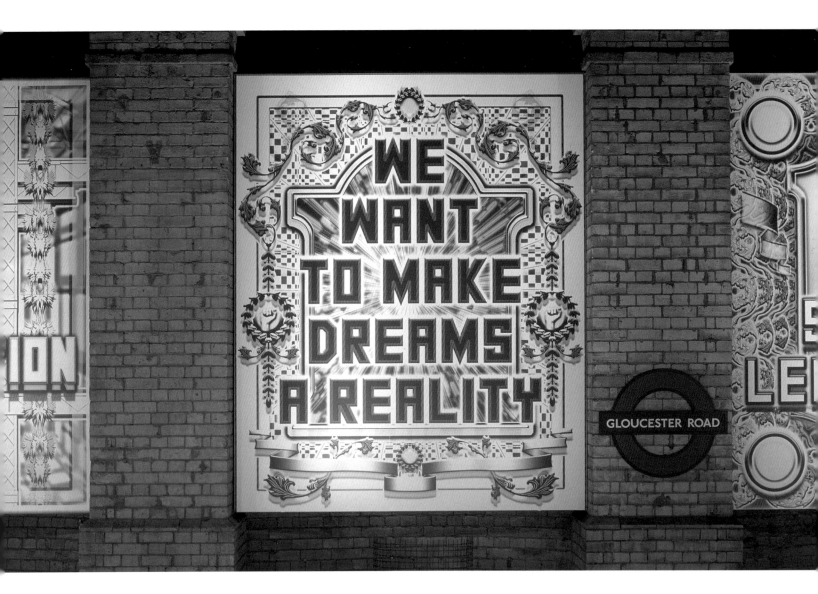

Griffiths' *Life is a Laugh* is the largest installation to appear at Gloucester Road and easily the most formally complex. Rather than neatly fit into the arches of the space like many of the other projects, the work runs in front of them and along the entire length of the platform, as Griffiths notes:

> It was important for me to work up a very different response to the site since I am a sculptor. But in this case I was aware of the fact that it would not be possible to walk around the work as is usually possible with sculpture. So what I decided to do was come up with a composition in which you could imagine interacting with the objects through the very space between them.

Mark Titchner,
I WE IT, 2004.
Detail of installation at
Gloucester Road.
Image courtesy the artist
and London Underground.
Photo: Stephen White.

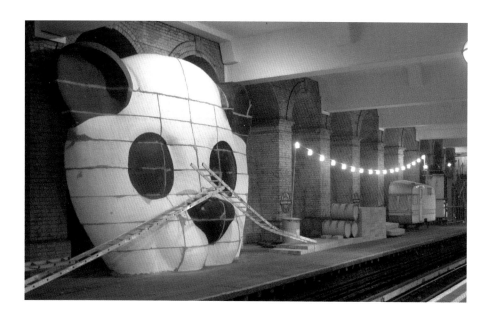

The work resembles an unfinished sculpture, as if it has been left for the viewer to complete the seemingly arbitrary elements through their contemplation of it by investigating the space between them. And unlike the other commissions, it cannot even be initially perceived at a glance since it is far too complex in construction, being constituted from found objects and assembled elements such as the giant 7.5 metre wide panda head. Regarding his selection procedure for these objects Griffiths comments:

> I wanted things to have a kind of weight and resonance to them — a very particular aesthetic that was loaded in order to create a totally emotive situation. The various elements all have their own place in this installational tableau which resembles a stage with props and theatrical lighting for an absurd drama that never takes place.

Each of the artists commissioned to develop a work for the Gloucester Road site respond to it in an entirely different way, deploying their own tactics to deal with the particularities of the site and way it is approached by the viewer, by staying within the parameters of the literal site. Batchelor, Milhazes and Aoshima all respond to the site and the viewer's movement through it by using colour and pattern. Titchner motivates his vocabulary to deal not only with the formal make-up of the site but also the ideology of the advertisements that make up a good portion of it. Griffiths develops an enormous installation that responds to both the sheer enormity and the oddness of the site — an enormous panda's head on a Tube platform? — to stimulate the viewer.

Brian Griffiths,
Life Is A Laugh, 2007.
Detail of installation
at Gloucester Road.
Image courtesy the artist
and London Underground.
Photo: Andy Keate.

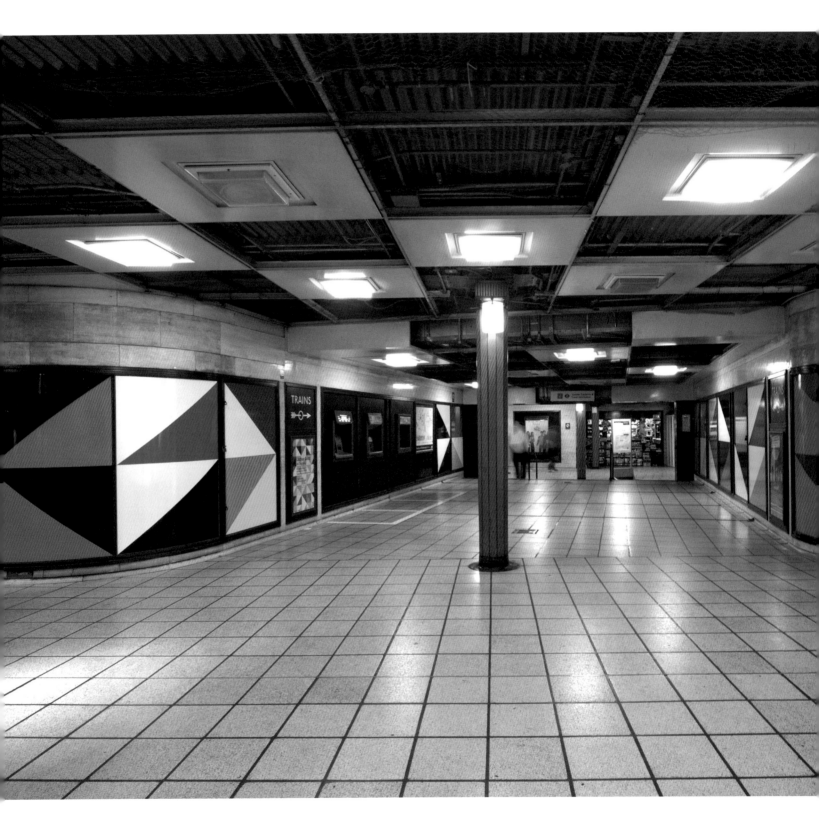

Chapter Two

Lothar Götz,
All Day Long, 2006.
Installation view at
Piccadilly Circus.
Image courtesy the artist
and London Underground.
Photo: Michael Franke.

The Piccadilly Circus site could not be more different in character to the one at Gloucester Road. Rather than being located adjacent to the platforms, it is in the cavernous ticket hall and corridors; where the space devoted to the PFA programme at Gloucester Road is long and narrow and perceived from a certain distance by the viewer (since it is located on the opposite side of them), the wall space at Piccadilly is circular and can seldom be perceived in one shot as it curves out of view in every direction. And where the projects at the Gloucester Road site overpower the surrounding advertisements due to their sheer scale – even when they aim to play off them, as in Titchner's case – those at Piccadilly are more firmly inserted into the fabric of the station's own vernacular signage and advertisement schemes. This means that in order to be effective they must either push harder to assert themselves against the context or seek to work with it much more intricately. The precise way each of the artists opts to address the viewer and their trajectory around the space is, by necessity, thus quite different to those chosen by artists at Gloucester Road.

By example, Lothar Götz's project *All Day Long* nimbly inserts itself into the given context by making a point of correspondence with much of the work discussed in Chapter One through the use of bold colour rhythms. But rather than offer a serene landscape setting or awaken the viewer as they flit past, Götz uses colour to choreograph the viewer around the space by establishing a series of contrapuntal rhythms. Not as straightforward or inflexible as to simply be a type of colour coding, *All Day Long* is instead akin to a sensory device to navigate the viewer from the outer parts of the ticket office into its hub. This sensitivity to the space can partly be put down to Götz's fascination with the architect of the space, Charles Holden, and specifically his use of colour, exemplified by the orange pillars punctuating the ticket hall. Amongst all the architects of the various Tube stations, there is the sense that Holden had the keenest purchase on how to work closely with the user of his spaces. From the very beginning, Pick attested to this in a note he made: "The station will be simply a hole in the wall, everything being sacrificed to the doorway and some notice above to tell you to what the doorway leads. I have got Holden to see that we do it properly."[6] The same qualities Pick found in Holden's architecture interest Götz today.

In commenting on his project, Götz refers to his interest in Holden by illuminating his unique response to the site: "I wanted to create something which looks as if it has always been there and becomes an obvious part of the station, a decorative element like a mosaic or tapestry." Where many of the PFA projects try to stand out against their context Götz is interested in

doing quite the contrary by ensuring that his contribution recedes into the architecture of the station.

Henna Nadeem purported to also navigate the viewer around the space of the entrance and the ticket office at Piccadilly through the use of a rhythmic pattern with her project *Trees, Water, Rocks*. But where Götz opted to use strongly coloured geometric configurations, Nadeem inserted polyphonic patterns – each element of which had been separately transposed from a variety of Western contexts, whether it be a wallpaper pattern or an image from an illustrated picture book. These rhythmic patterns were expertly cut out from their source in the shape of Islamic patterns that made a sharp point of contrast with them; they were then resized and collaged together. As a result, when the viewer passed through the ticket hall, rather than being choreographed by something that seemingly represents an undecipherable abstract coding, the viewer was softly brought around the corners of the space and teased into the abstract landscape image created by the patterns only to be brought back to their surface by the frames containing them. Nadeem was thus also interested in the viewer's interaction with the space and how her work could affect this but in an entirely different way to Götz.

Thin Cities marks the centenary of the Piccadilly line itself, celebrating its past, present and future. Originated by Gavin Wade and conceptually shaped and delivered in collaboration with the PFA curatorial team, *Thin Cities* is both inspired by and named after a section in Italo Calvino's labyrinthine novel of magical realism *Invisible Cities*, 1972, a book which unfolds through a notional dialogue the Emperor Kublai Kahn enters into with the infamous explorer Marco Polo via a series of vignettes such as the following one:

> … setting out from there, I will put together, piece by piece, the perfect city, made of fragments mixed with the rest, of instants separated by intervals, of signals one sends out, not knowing who receives them.

Getting a sense of this rich setting is crucial to comprehending both the scope of *Thin Cities* and grasping its premise since the series is most accurately conceived as being set within a magical landscape where the notion of the city is fictional and metaphorical rather than being literal and actual. Wade conceives of the artists he invites as explorers and storytellers. Instead of just responding to the literal facts presented by the site – including its precise properties and the way the user interfaces with it – Wade encouraged the artists he selected to think more about the history of the site and the narratives and stories (imagined or real) associated with it. Wade:

Rut Blees Luxemburg,
Piccadilly's Peccadilloes, 2007.
Detail of installation at
Heathrow Terminal 4.
Image courtesy the artist
and London Underground.
Photo: Andy Keate.

I wanted to develop a project that might approach the complexity of the site itself and I felt that fiction was a strong way of dealing with this. Foregrounding fiction would, I hope, begin to set out the very different ways that people who use the line could perceive the same connected world…. I see Calvino's fiction of Marco Polo's storytelling as a way of both romanticising the journey of a Piccadilly line traveller – as an explorer – and of potentially highlighting a sense of how you as an individual impress upon any given situation your own fiction of the world.

So Wade's conception of the notion of the site is neither literal or functional: it is fictional.

Thin Cities runs along the Piccadilly line and consists of a panoply of individual projects and events commissioned in response to specific stations on the line. The series has its own animated interactive website that nestles within the overall PFA website designed by the innovative graphics group Red Leader. One aspect of the website consists of a map of the Piccadilly line, the projects plotted along it, with a circular marker designating Jim Isermann's Tube wrap shuttling up and down the line to enhance its animated element. Clicking on any one of the points designating a project brings up the information pertaining to it. The website also allows the viewer to respond to the projects by sending in their own stories and anecdotes regarding the individual works or stations at which they are sited; Oyster card wallets designed by Richard Woods, Asia Alfasi, Heather & Ivan Morison and Simon & Tom Bloor can be requested via the website; and a weekly changing podcast by Heather & Ivan Morison, a work also located at the Knightsbridge Tube station, of 52 wildlife sound recordings of migrating animals culled from

Rut Blees Luxemburg,
Piccadilly's Peccadilloes, 2007.
Top Left to right — Bounds
Green and Rayners Lane
Bottom — Arnos Grove
and Oakwood.
Images courtesy the artist
and London Underground.

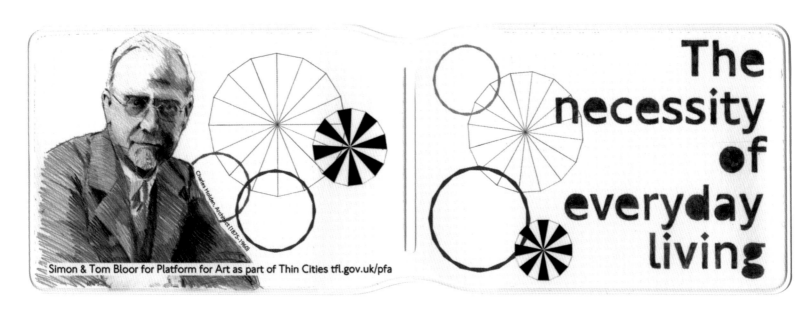

The necessity of everyday living

Charles Holden Architect (1875-1960)

Simon & Tom Bloor for Platform for Art as part of Thin Cities tfl.gov.uk/pfa

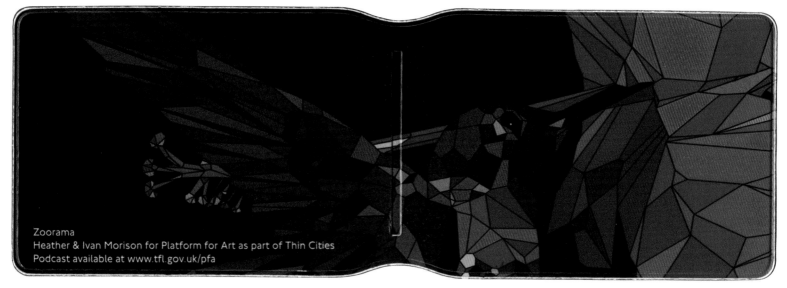

Zoorama
Heather & Ivan Morison for Platform for Art as part of Thin Cities
Podcast available at www.tfl.gov.uk/pfa

Oyster card wallet designs.
Top – Simon & Tom Bloor.
Bottom – Heather & Ivan Morison.
Images courtesy the artists
and London Underground.

the British Library sound archive is available to download. With these devices, expertly conveyed by the designers, Wade is attempting to build up a rich discourse which is initiated by himself and responded to both by the artists and now by the public too through its interactive dimension. Using the web and the tools of graphic design as an active extension of the work – as a relational tool – rather than merely an information point is crucial since it further draws the viewer into the programme by creating another point of interface. The website also works to extend Pick's ideology from the 1930s in which the graphic informational aspects of LU are indistinguishable from the aesthetic ones and the latest technologies are actively sought out and put to work in order to achieve its strategic aims.

Richard Woods completed two projects for *Thin Cities*, one sited at Leicester Square and the other at Green Park (both titled *Logo No. 26*). The work sited at Leicester Square hugs the cylindrical booth that occupies the centre of the station's ticket office and consists of multi-coloured, cartoon-like, mock wood planks that appear to coat the booth. Where the site is usually used to display information or advertising, Woods' *Logo No. 26* simply advertises itself – which is to say it does not really function as an advertisement.

Richard Woods,
Logo No. 26, 2007.
Installation view at
Leicester Square.
Image courtesy the artist
and London Underground.
Photo: Declan O'Neil.

Jim Isermann,
Piccadilly line Tube wrap.
The artist at the launch
in Northfields.
Image courtesy the artist
and London Underground.
Photo: Sussy Ahlburg.

A key project within the *Thin Cities* programme is surely Jim Isermann's Tube wrap. Isermann found a way to create an artwork by not adding too much to the existing visual information offered by LU – the geometric design of the 'wrap' could almost have come from LU's design team, and this is part of the point. But the very concept of undertaking the wrap in the first place could only have come from an art programme – in this case an artist with a deep interest in design. Regarding his contribution to the PFA programme Isermann comments:

> The design of the artwork for the Tube wrap addresses my ongoing investigation of the logic and geometry of repeating patterning. In specific, this piece is inspired by the severe fundamental volumes of Charles Holden's architecture and the repetition of that language…. My artwork, like much of my work, is determined by limitations. In this case, a design that is not so graphic or animated as to destabilise commuters…. This resulted in a exceedingly subtle and monochromatic design with a shocking colour exchange [only] at the doors.

Consisting of an entire Tube train coated with a blue and orange geometric motif, the Tube wrap is so inconceivable within what is normally accepted

as art on the Underground that its very literalness – simply wrapping a Tube – is cancelled out. In common with a number of other works in the PFA series, the Tube wrap enters into dialogue with advertising – the strategy and materials used in its fabrication bring to mind the advertisements that adorn London buses which are often wrapped in enormous advertisements for products. But rather than offering a critique or assessment of the deployment of such strategies in advertising, the Tube wrap mimics the strategies used – the large scale, the sticker-like coating – without offering up a specific message in order to communicate effectively with the viewer. Though it could be suggested that as a result the work advertises both itself and the *Thin Cities* series it really is too abstract and blank for that. For the initiated, the bi-coloured geometric abstract shapes refer more to the development of the vocabulary Isermann has built up throughout his career and the way this corresponds with certain elements of LU's Tube designs – particularly the fabric used to coat the Tube's seating which often has a retro 1970s feel to it. As Isermann mentions himself, his work "comments on Charles Holden, who was recognised for his 'total design', integrating sculpture, textile design and the detail of every fixture". In this sense, the Tube wrap invokes the general realm of this visual language rather than actually referring to a specific element of it. As a sign, it is totally unmotivated and so the Tube wrap slips below the frequency of communication the other PFA projects use. Isermann is highly attuned to this and interestingly perceives of it as an aspect of his notion of site-specificity: "I think my public works are most successful when they are so site-specific that they are not necessarily immediately recognised as art." If they are not recognised as art it is because they are mistaken as being part of the design.

Thin Cities creates its own way of accessing an experience of the city. Since this is accessed through the different projects constituting the series each one of these experiences is quite different in kind. Calvino's work of fiction acts as a useful ruse to assist the curators imagine the series, the individual artists to respond to the brief set, and the viewer to comprehend something of its tone and spirit.

Jim Isermann,
Piccadilly line Tube wrap.
The wrapped train prior to the
launch at Northfields Depot.
Image courtesy the artist
and London Underground.
Photo: Andy Keate.

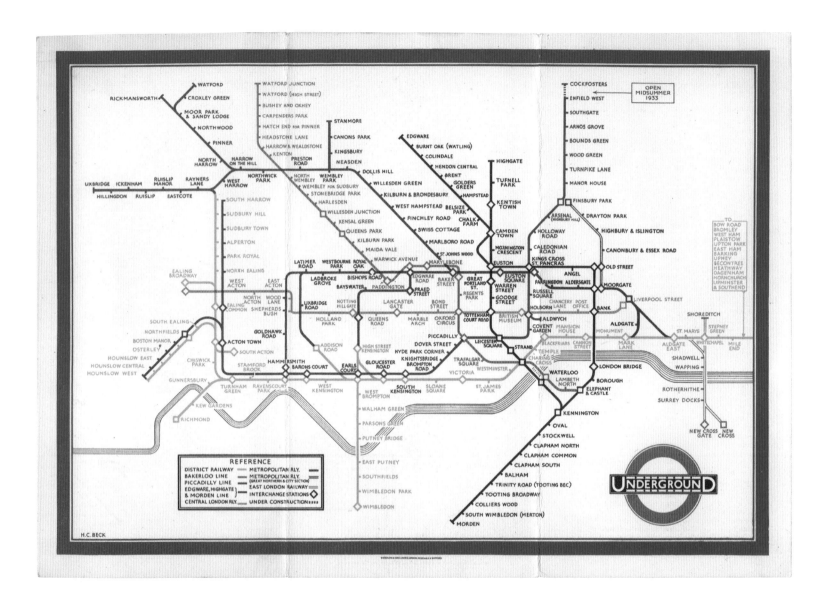

Harry Beck, 1933 version
of the Pocket Tube Map.
Image courtesy the London
Transport Museum.
© TfL/London
Transport Museum.

Chapter Three

The Tube map cover designs consistently question the role of art on the Underground as they are part of an overtly functional aspect of the literature associated with the network (even if at times the designs generated by the invited artists work to defamiliarise it). Certain aspects of the LU programme sit on a layer above the gritty functionality of the Underground network and the literature that is necessary to make it work but the Tube map cover designs (along with the Tube wrap) are actually an integral part of it. In this sense, they relate to the notion of the functional site discussed in the Introduction, a concept used to convey how works that have an active role within their context, often involving them being mobile, actually operate. Crucially, in this case such a status is only achieved through each artists dialogue with design. The Tube map cover designs are also one of the only series within the PFA programme that is produced en masse, with over 15 million copies produced each year.

The development of the design of the Tube map is crucial to gaining an understanding of the Tube map cover designs generated by these artists. During the height of Pick's activity in the early 1930s the LU network had expanded so considerably that it was increasingly difficult to squeeze all the new lines and stations legibly onto a geographical map. The draughtsman Harry Beck initially submitted a new diagrammatic means of representing both the various stations and their intersections and in 1933 Pick commissioned him to produce an official one as a part of his total design scheme for LU. Basing his map on an electrical circuit, Beck represented each line in a different colour and interchange stations as diamonds; the previously crowded central area was enlarged for reasons of legibility and the course of each route was simplified into the form of a vertical, horizontal or diagonal line. Even though it has been updated as new lines have been added to the network, the same basic schema is still used for the Tube map.

Each of the designs produced by the artists invited to participate in the Tube map cover design series thus far is very much premised on the concepts and vocabulary developed in their work to date. With elements of each artists vocabulary merged with aspects of the Tube map the result is something that, although it signifies the usual Tube map lies inside the covers of the pamphlet, certainly defamiliarises it. Each of the artists pushes this notion of defamiliarisation to a different degree and with a different purpose in mind.

Out of the series, Gillick's *The Day Before (You Know What They'll Call It? They'll Call it the Tube)*, Yinka Shonibare's *Global Underground Map* and Jeremy Deller's *Portrait of John Hough* (see pages 101–103) appear to be

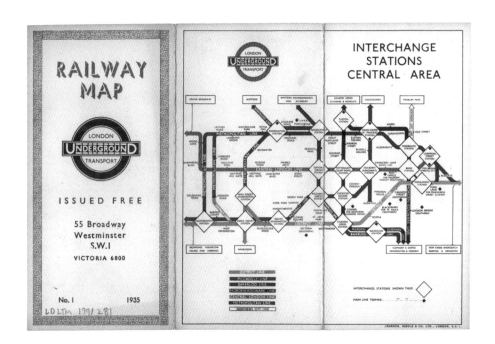

the least abstract of designs since they motivate the colours associated with the various Tube lines or its very history and context in a particular direction. Gillick's design relates to the premise of his entire practice, economically communicated in the following quote: "I think… about the semiotics of the built world, the language of how things are constructed, added-to, moderated and renovated." What interests Gillick generally is working with things that already exist, what he refers to as the "semiotics of the built world". In this case, what Gillick does specifically with his design is to moderate the language of the Tube map itself and use it in a reconfigured way. Gillick is drawn to moments in history where crucial events and what he terms Eureka! moments occur. The design for his cover spells out the words "friday january the ninth eighteen sixty three", the last day on which London went without an Underground system, which to his mind is a day with a very particular resonance, hence he was compelled to make a work about it. Setting these words out on a grid system and then colouring them using the various colours of the Tube map, a suitable design was developed.

Shonibare's *Global Underground Map* takes the colours of the different Tube lines and liberally applies them to a world map. The apparent arbitrariness of this gesture – the mapping of the language from one map onto another – retroactively brings a number of questions to bear on both of the maps and the histories they represent. For centuries, world maps were drawn and the various countries plotted by the ruling nations and classes who had an investment in the way their countries were portrayed. As a result, Western

Pocket Tube Map, 1935.
© TfL/London
Transport Museum.

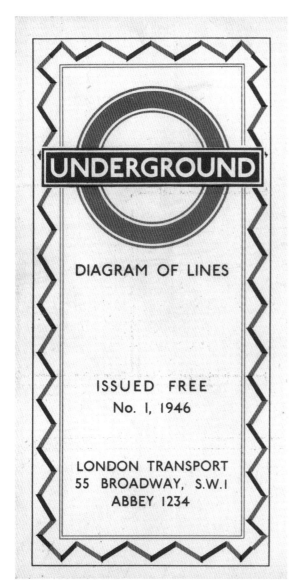

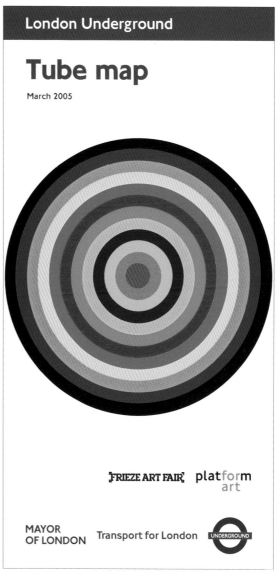

Pocket Tube map
cover, 1946.
© TfL/London
Transport Museum.

Emma Kay,
You are in London, 2004.
Tube map cover August 2004.
© Transport for London.

states were often represented in a disproportionate way while entire African nations appeared to dwarf in comparison. The contours of the map Shonibare uses are based on a newer map premised on the work of the historian and cartographer Dr Arno Peters which was drawn up in 1974 with a more objective means of representation since it is based on each country's actual land mass. In the past, the earlier out of proportion maps were coloured in a very particular manner and the colours were indexed in such a way that they represented issues concerning population density or volume of trade and economic activity – supposed signifiers of a country's development and success – and so once again Western countries always came off the best. By transposing the colours used on the Tube map onto the world map Shonibare exposes the arbitrariness of these colour systems. The landmasses of the work have been divided up by superimposing an invisible grid similar to those created by the lines of latitude and longitude used in the Tube map.

At the same time Shonibare's design for the cover of the Tube map also comments on the ethnic diversity of London itself since more than any other city in Europe it has a rich ethnically mixed history and post-colonial present. Instead of literally representing this, what Shonibare does is to gesture at it in an abstract way through his transposition of one mapping system onto another. The resulting design appears like a rich global patchwork, implying that London is a microcosm of the world.

Deller's cover (produced with Paul Ryan) depicts John Hough, the longest serving member of Transport for London staff. The design taps into the history of the LU network not so much through its design but because it represents one of its workers who so often are rendered invisible through the abstract coding that large corporations use to both advertise and communicate with a wide audience. Throughout his practice, Deller is consistently drawn to specific characters and finding ways to present their stories rather than abstract schema.

The covers by both David Shrigley and Emma Kay are much more playful but in so being are no less effective. Much of Shrigley's previous work is presented through his drawings and cartoons that often depict amusing scenarios as a way to send up a variety of situations and clichés. For his cover design, humorously titled *Map of the London Underground*, Shrigley scrambles all of the lines together – resulting in a mess of lines and colours that resembles the way an a.a.p. cartoonist, the famous American cartoon distribution company from the 1950s, may have chosen to illustrate a brawl between two opposing characters. The design pokes fun at Beck's original

London Underground

Tube map

February 2006

DAVID SHRIGLEY

MAYOR OF LONDON Transport for London UNDERGROUND

design which, although graphically successful in the way it reduced a complex network down into a number of lines, can nevertheless be confusing for the user, especially the first few times around. Shrigley has surely witnessed people standing in front of a Tube map in any given station with a blank look on their face as they ponder how to get from one destination to another. At the same time he could also be commenting on his experience as someone who lives in Glasgow and travels to London frequently and has to face the Tube map.

Emma Kay's design *You Are in London* brings into play numerous art historical references – in a way it is like a succinct visual archaeology of a certain form of art history – from a time when members of the avant-garde such as Sonia Delaunay used the target motif as a symbol of modernity. The fact that this moment in time also coincides with the actual design of the Tube map itself and that the avant-garde members who used this form of pared back graphic language were also designers was surely not missed by her. Not actually referring to a particular moment in this history or making any form of direct comment on it instead Kay's design injects the formal elements from this history into her vocabulary and uses it to communicate in an effective and economical way with the viewer. Through its high visual impact, Kay's design reaffirms the viewers presence in London and hence its use on the cover of this book.

More than any of the other strands of the PFA programme discussed thus far the Tube map cover designs establish a crucial dialogue with the literature associated with the Underground network and in so doing establish a further link with the viewer (here reconfigured as a user). In no way would these cover designs operate without this precise context and the way it engages the viewer. A comment Gillick made in an interview about his work judiciously refers to this: "My work is like the light in the fridge: it only works when there are people there to open the fridge door."

David Shrigley,
*Map of the London
Underground*, 2006.
Tube map cover February 2006
© Transport for London.

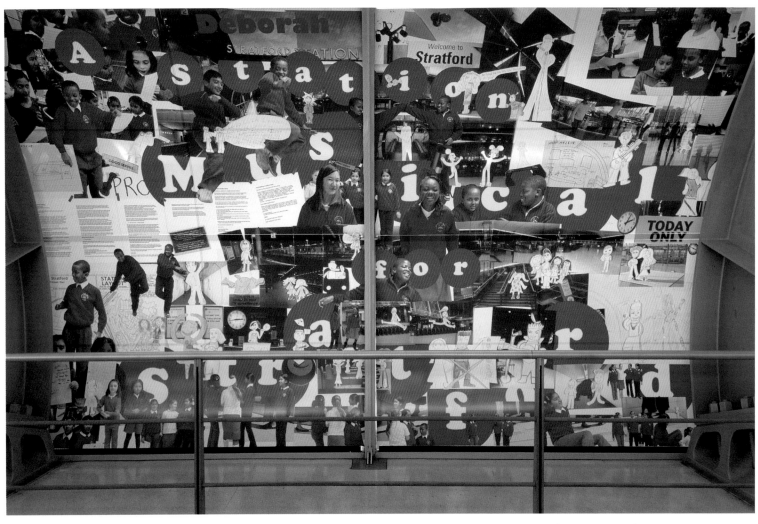

Chapter Four

The Platform for Art programme integrates a range of projects that allow for the direct engagement and participation of local communities and other groups of people. While these projects share some of the same goals as those within the programme at large, the methods by which they are achieved can be quite different. Whilst the artist remains at the centre of the creative process this area of the programme develops strategies to share the creative role of the artist with a broader community of non-professionals, whether they be from a school group, residents from a particular location, or drawn from the wide pool of LU staff. In so doing the projects not only tap into the history of community based art but also the art of the collective. The notion of the functional site and its associated concept of the relational is also crucial here since the site is activated by this collaborative element and the precise way it involves communities in both the production and reception of the work.

Many of the projects involve an artist working closely with a particular community to develop a project, the method they put in place to work with the community and develop the project by necessity being different in each case. So too is the way they frame the results of the project visually. For rather than finding the final form of the work by transposing a generic signature style onto a specific scenario, the leader or administrator of each project must find a totally new and innovative way of presenting the research produced during the project. Each leader has found a different way to do this depending on the nature of the brief, the community and the site.

For *A Station Musical for Stratford* Ella Gibbs and Amy Plant conducted a series of workshops with a range of people including children from Carpenters Primary School, which has become well known locally for being the closest school to the site for the London 2012 Games. The brief was to produce a project that responded to local residents' feelings about their area and its selection as the location for the Games. During the open ended workshops that underpinned the project Gibbs and Plant set up a studio in Stratford station where customers and staff could 'drop in' to take part. They encouraged participants to explore their own individual conception of their area through a diverse set of media, including drawing, painting, film, photography and dance. The idea was to arrive at the basic elements from which a new temporary artwork could be developed; a work that would, in Gibbs' words, "put forward a proposal for something that would never actually happen rather than a finished work of art in its own right". Instead of just inviting the students, customers and staff to respond to the future of the area — ever present because of the countdown clock to 2012 assembled outside the station — the artists encouraged them to respond to its past and present:

Ella Gibbs and Amy Plant,
A Station Musical for Stratford, March 2006.
Installation at Stratford station.
Photo: Daisy Hutchison.

The commission was site-specific but it was also time-specific in the sense that it responded to the concerns circulating at that particular moment in time. Instead of the project being part of a big overblown celebratory countdown for the 2012 games we wanted to celebrate the history and diversity of Stratford.

The results were edited by the artists and rescaled and collaged into an overall image which in turn was then re-edited and fashioned into a new large-scale frieze for the station through collaboration with the design team Åbäke. The team also added the names of all the participants using a customised version of the font Gill Sans Ultra Bold, forming a link with Johnston who created LU's own typeface and who was Gill's tutor. The font for the centre piece of the frieze is actually appropriated from a poster for *Oh! What a Lovely War*, a musical that took place at Stratford East theatre in 1963 and provides a further point of correspondence with the area's history. One part of the frieze uses individual tube tickets as a background and then collages a series of images of the participants' of this; in another part of the frieze, a series of loose handmade drawings create a backdrop for the graphic rendering of some of the participants names. The East London music training organisation Urban Development were also invited to participate in the project and run a series of sessions with the children to generate a new song about Stratford to be aired during the project's launch. *A Station Musical for Stratford* was a multi-faceted project that involved different groups in the collaborative process of the production of the work of art.

Suki Dhanda's project *Year of the Dog* commissioned to celebrate the Chinese Zodiac Year of the Dog featured a number of photographs of dogs with their owners, each one emphasising a different aspect of the relationship between the human and the canine. For Dhanda: "The most important thing was to capture the diversity of London's dog owners. Though not wanting to enhance stereotypes regarding owners selecting their pet based on shared characteristics, curiously they were what I actually found — the Essex boys with their bull terrier, for example." In another one of the images a young woman stands behind her rottweiler in a night time park setting; the dark menacing colour of the dog finds its correspondence in the black leather jacket adorned by the woman. In another image again a couple are pictured in an interior setting, the man holding their bulldog lovingly in his arms. A key element of the project came with PFA's invitation to the public to send their images of themselves with their pets in to be uploaded on their website. The viewer hereby became an active participant in the production of the visual information surrounding the artwork.

Suki Dhanda,
Christina and Ifestos, 2006.
Image courtesy the artist.

One of the goals of the community projects is to build up advocacy for the PFA programme amongst staff members. Realised in conjunction with the Whitechapel Art Gallery, *Platform Portraits* involved the creation of a series of photographic self-portraits of LU staff. Inspired by the concurrent Whitechapel exhibition of Gerhard Richter's *Atlas* – an archive of images arranged by the artist on a series of pin-boards – *Platform Portraits* was facilitated by a number of workshops at the gallery led by photographer Rose Butler, during which LU staff members gained familiarity with photographic equipment. Each of the portraits produced during the project is completely different and gives a perspective onto the individual's sense of their role within the organisation. One photograph shows three members of staff who are huddled together with heads bowed; while they fill three quarters of the image, the top quarter is left clear so that a LU information sticker is clearly legible: "Surveillance cameras in constant operation" it reads. The image is surely a little in-joke amongst staff members on the way they are constantly watched during their working hours. A further photograph from the series

Suki Dhanda,
Mark, Bulent, Daniel, Lady and Casper, 2006.
Image courtesy the artist.

Suki Dhanda,
Anita, Raphael, Isabella, Alfie and Amadeus, 2006.
Image courtesy the artist.

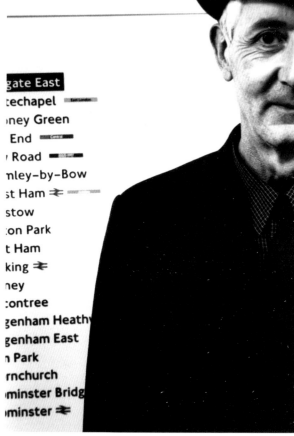

depicts a member of staff glancing upwards towards a station clock, the time on which reads 4:15. Both the top of the clock and the body of the staff member have been cropped out of the image and this odd composition adds to its unusual spatial atmosphere; rather than getting the sense that the staff member is waiting for their shift to finish there is a feeling that she is gazing thoughtfully at the vintage clock as if it was a desired item. A third image in the series depicts a more mature member of staff standing boldly in front of a poster for the Hammersmith and City line – half of his body and half of the poster cropped – as if in proud defiance of his association with the line and his job in serving its users. The use of black and white photography is apt both because of its role in photographic portraits historically and in view of how it serves to convey a more forceful sense of character as it brings the lines on peoples faces into crisp focus. A further project, *Stations of the Future*, also served to involve LU staff in the creation of a visual work.

London Underground
staff in collaboration
with Rose Butler, *Platform
Portraits*, September 2004.
Aldgate East station.
Image courtesy the artist.

On this occasion however it was in the form of an imaginative response to a competition that was established and communicated through a poster designed by Nils Norman as part of the *Thin Cities* programme. There were five categories of entrants: Five—11s, 12—15s, 16—19s, Adults and LU staff. Georgina McIntyre, the winner of the LU staff category, produced a futuristic image of two multi-faceted pods orbiting around a landing platform bearing the LU logo (see page 120). Both of these projects offer LU staff members the opportunity to become part of the discourse on the network itself.

The communities projects serve to bring individuals usually not involved in art to the scene of its production and distribution. By so doing the projects are able to engage with issues pertaining to specific localities and the individuals associated with them. The vast London Underground network serves a customer base that makes for a very large and diverse audience for art. The range of contexts from which to draw upon and engage people has led to projects produced with groups from Borough Market traders to the Womens' Institute and from homeless people to Arsenal football fans, as well as students from many colleges, such as London College of Fashion, Southwark College and Wimbledon College of Art. The communities programme adds an almost anthropological dimension to PFA as places are understood not so much through issues pertaining to abstract notions of space and identity but specific concerns regarding communities and the way they create their own spaces to live and work in.

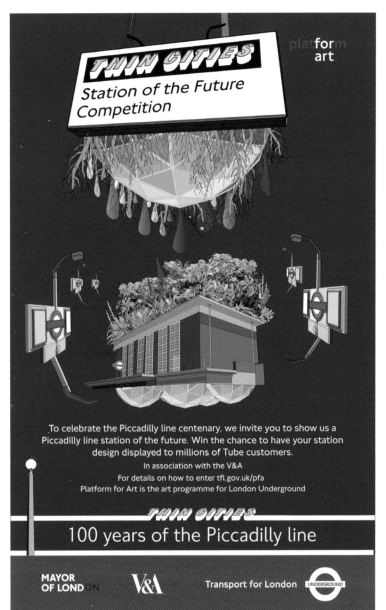

Left: *Station of the Future Competition* promotional poster, Nils Norman, various stations, August 2006. Image courtesy the artist and London Underground.

Right: *Futuristic Space Station* by Jessica Katanga (Winner of Children's category), 2007. Image courtesy the artist.

Conclusion

Ultimately, the PFA programme aims to bring a broad variety of artworks to an audience who in part are unused to experiencing art so that they might reconsider the arena in which they are traveling and also what art can be and do. One way this has been achieved is through inviting different artists to work with the same space or site, whether it be Gloucester Road or the cover for the Tube map, and follow how they respond to the same brief in entirely different ways. At other times it has meant commissioning art to appear in the most unexpected of places and in the most unexpected of forms, such as the soundwork by Heather & Ivan Morison at Knightsbridge station. Either way the key has been to ensure that the projects become a part of the viewers' everyday experience of the network.

Fresh perspectives are constantly injected into the curatorial premise of the programme in order to ensure that it is both critically kept in check and also expanded to accommodate new approaches as contemporary art develops. *Thin Cities* was one such attempt to do this through the introduction of a fictional conceptual remit.

Permanent projects are also important since they would allow the programme to become a consistent part of the vocabulary of LU stations and a permanent presence on the network. The opportunity to do this presents itself in the form of working alongside the current modernisation programme taking place throughout the network which in turn can establish a longer term legacy for the PFA programme.

It could be conjectured that the most dynamic PFA projects have occurred and will continue to occur in the future when artists are invited to establish a vital connection with the LU network. No matter whether they engage with the existing identity and design of its literature – as is the case with Shrigley and Isermann – or a narrative from the network like Deller does. In these instances, the notion of the functional site and the relational are driven by artists' interventions into the discourse of design. These PFA projects also come the closest to Pick's founding vision – albeit within a contemporary critical landscape – whereby a thoroughly interrelated design and art experience is striven for.

The Introduction underscored how one of the vital strengths of the PFA programme is the way it seeks to map the heterogeneity of contemporary art onto the complexity of the LU network and then attempt to coordinate the two together. Only by maintaining this strategy can PFA ensure that the vitality of their programme is assured for the future.

1 Meyer, James, "The Functional Site", *Documents*, no. 7, Fall 1996, pp. 20–29.

2 Bourriaud, Nicholas, *Relational Aesthetics*, *les presses du reel*, 1998, (English translation 2002), p. 14.

3 Bourriaud, *Relational Aesthetics*, *les presses du reel*, 1998, p. 112.

4 Art projects on LU did not stop there. For instance, in the early 1980s Eduardo Paolozzi was commissioned to produce a series of mosaics for Tottenham Court Road station and Robyn Denny produced a mural for Embankment station in 1985.

5 Frank Pick as quoted in Jeremy Rewse-Davies, "London Transport Design", *Modern Britain: 1929–1939*, eds. James Peto, Donna Loveday and Alan Powers, Design Museum, London, 1999, p. 98.

6 Frank Pick as quoted in Jeremy Rewse-Davies "London Transport Design", pp. 97–98.

Beatriz Milhazes,
Peace and Love, 2005.
Detail of artist's drawing
for Gloucester Road.
Image courtesy the artist.

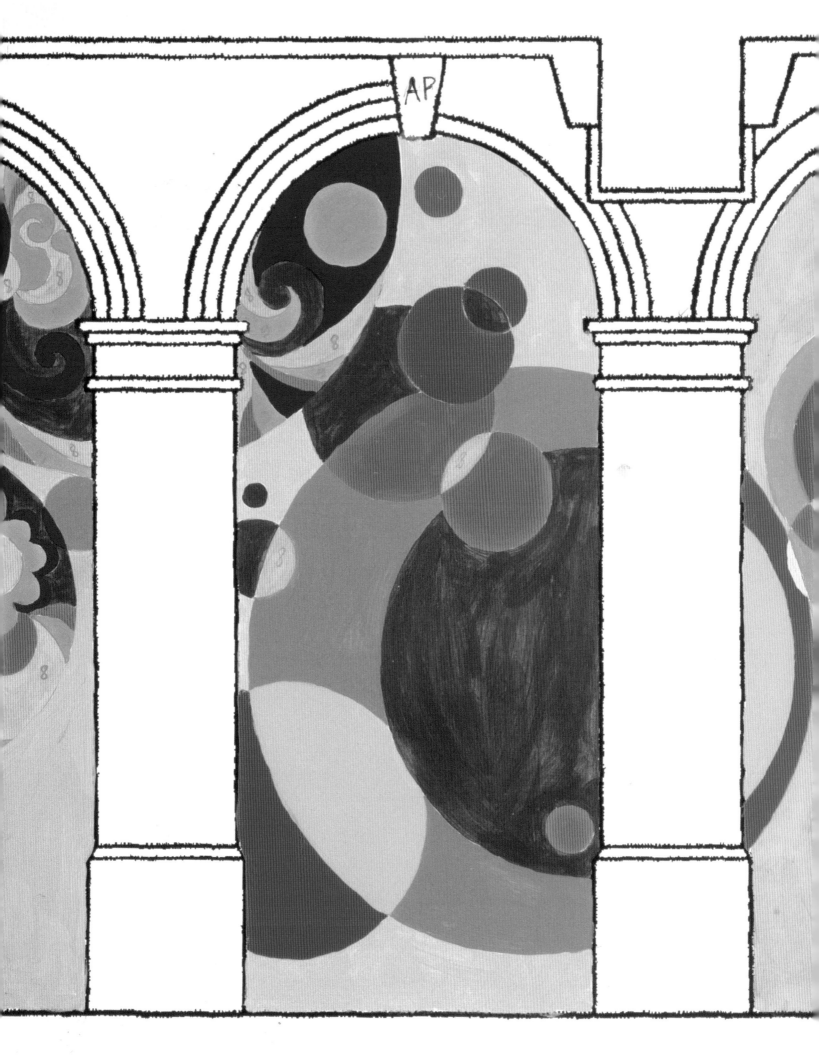

GLOUCESTER ROAD

Brian Griffiths
Life Is A Laugh

July 2007 – May 2008

Life Is A Laugh was the first large-scale sculptural work to be realised at Gloucester Road. Building on an increasingly ambitious programme of projects at the site, the work made the leap from predominantly discrete two-dimensional wall based works to using the platform as an architectural environment as a whole, taking on the notion of site-specificity through formal sculptural discourse as well as conceptual framing.

Griffiths almost nonchalantly proffered the disused platform as a 'big shelf' upon which an incongruous collection of objects had seemingly been haphazardly stored by an unknown character. Upon closer inspection the objects formed a helter-skelter assault course over which the eye was encouraged to wander. The artist succeeded in bringing together wildly inappropriate objects such as a 7.5 metres wide concrete panda's head, half a classic 1970s caravan, a working lamp post from the M42, a pile of bricks, a string of lights and two scaffolding ramps in a manner that made them somehow appear quite at home on the Underground.

Formally and conceptually Life Is A Laugh simultaneously pilfered from the languages of the theatre, film and the industrial site collapsing materials and objects together in an idiosyncratic sculptural bricolage that formed complex visual narratives and associations for the viewer. This was an uncompromising artwork in a highly public setting built from overtly familiar materials in a fashion that both engaged and distanced the viewer as a means of prompting an examination of the environment and the audience's relationship with it.

Brian Griffiths was born in 1968 in Stratford Upon Avon. He lives and works in London. He studied at University of Humberside followed by Goldsmiths College, University of London from 1995–1996. He is represented by Vilma Gold Gallery, London and Galeria Luisa Strina, Brazil. He has shown extensively both in the UK and internationally and his work is in private collections such as the Saatchi Collection, The Zabludowicz Art Trust and the Arts Council Collection.

Brian Griffiths,
Life Is A Laugh, 2007.
Detail of installation
at Gloucester Road.
Image courtesy the artist
and London Underground
Photo: Andy Keate.

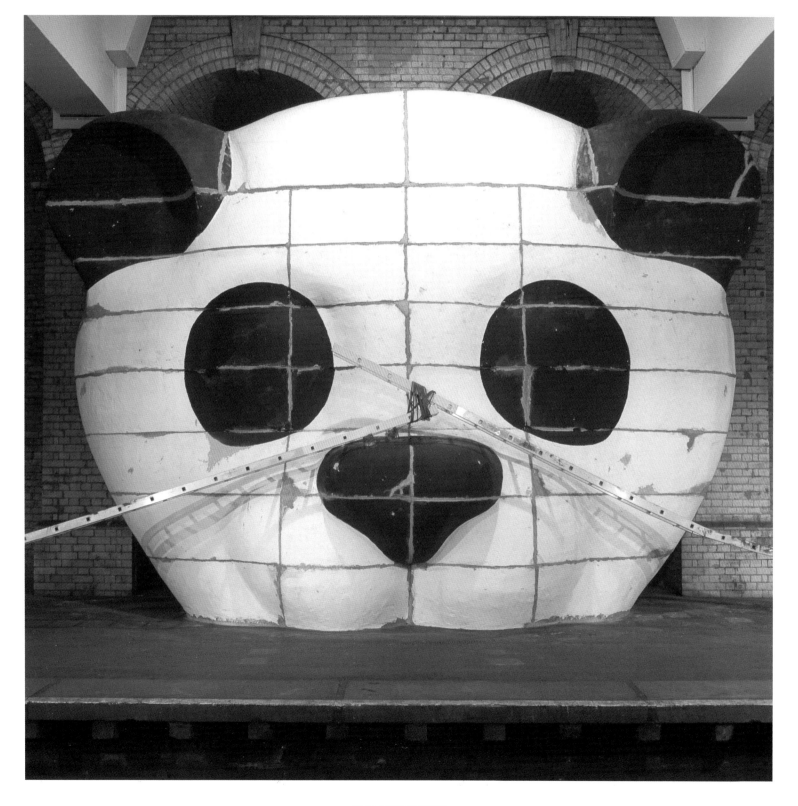

Chiho Aoshima
City Glow, Mountain Whisper

July 2006 – April 2007

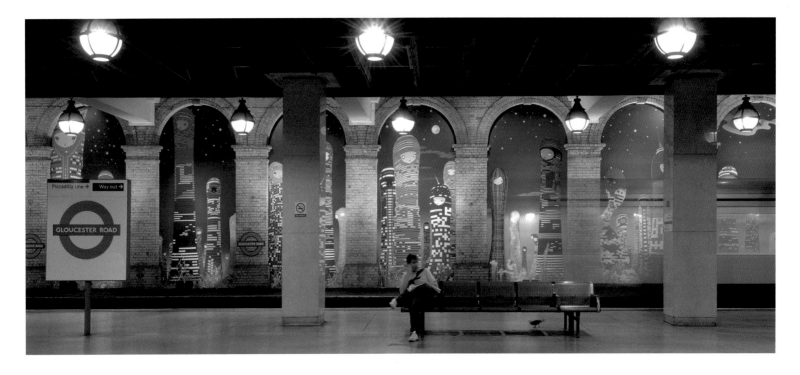

City Glow, Mountain Whisper was Chiho Aoshima's first major public art commission in the UK. For the work, Aoshima interpreted the bustle and energy of the city, and the desire for calm within it, with a towering cityscape eventually receding to a welcoming hillside.

Aoshima's work transcends traditional representation, working in a digital medium to create unique and extraordinary worlds full of young women, spirits, invented creatures and exquisite natural landscapes. Aoshima renders fantastical imagery in a singular style that seamlessly integrates the age-old tradition of Japanese scroll painting with the contemporary aesthetics of Manga, the pop phenomena of Japanese comic books and graphics.

Chiho Aoshima was born in 1974 in Tokyo, Japan. She is a high profile contemporary artist in her own right as well as being a member of Takashi Murakami's Kaikai Kiki Collective. Aoshima graduated from Department of Economics, Hosei University, Tokyo. She completed a residency at Artpace, San Antonio, Texas, in 2006. Aoshima now lives and works in Tokyo.

Chiho Aoshima,
City Glow, Mountain Whisper, 2006.
Installation view at Gloucester Road.
Image courtesy the artist, Galerie Emmanuel Perrotin, Paris/Blum & Poe, Los Angeles.
© 2006 Chiho Aoshima/ Kaikai Kiki Co., Ltd.
All rights reserved.
Photos: Daisy Hutchison.

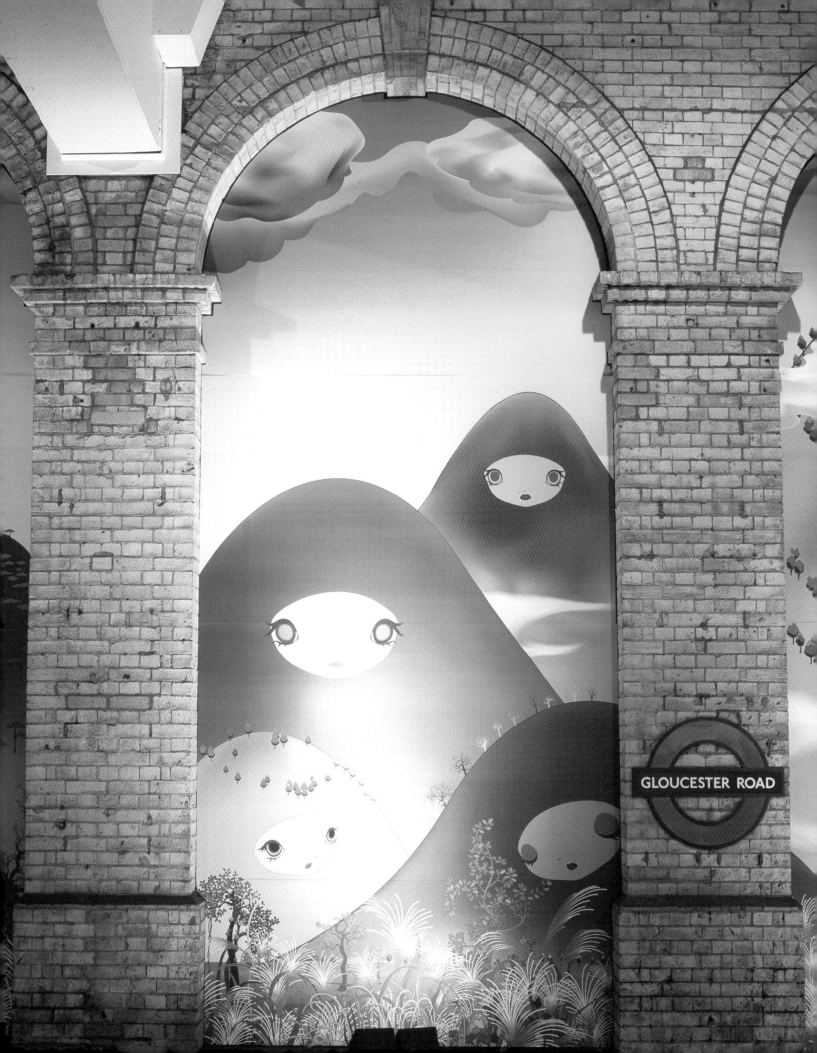

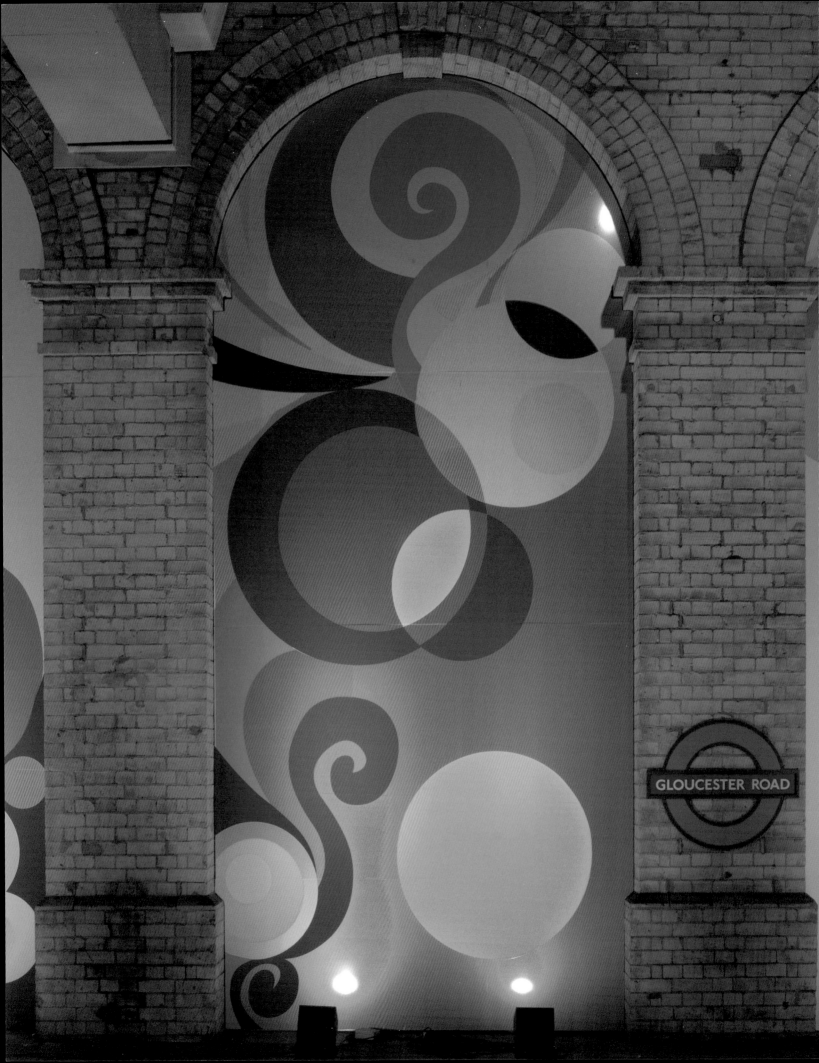

Beatriz Milhazes
Peace and Love

November 2005 – June 2006

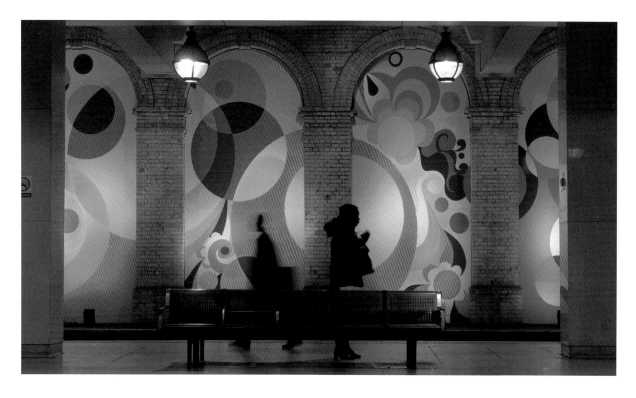

Peace and Love, by Beatriz Milhazes, was the first site-specific installation to extend the entire length of the disused District and Circle line platform at Gloucester Road station. This huge, colourful commission dominated an entire side of Gloucester Road station, creating a visual dialogue with both the static, monumental architecture and the constant movement of trains and travelers within.

Beatriz Milhazes' rich and complex work references motifs from her everyday environment such as flora and fauna, carnival and folk art, and the colonial Brazilian Baroque. Her continually expanding repertoire of influences also includes abstract patterns and ornamental arabesques, which play on the ambiguity between the recognisable and the unfamiliar. The beauty, harmony and violent contrasts in her work result in a colourful visual experience that is at once jarring and musical, full of unexpected tricks and treats.

Using a collage-like technique, Milhazes builds up intricately layered images whose surfaces pulsate with intense, vibrant colour. Each of the 19 large vaulted arches on the District line platform at Gloucester Road contained part of a dense, vividly-coloured, tightly-knit composition which skilfully manipulates complex elements into a balanced whole.

Beatriz Milhazes was born, lives and works in Brazil. Internationally renowned, she has exhibited worldwide and represented Brazil at the Venice Biennale in 2003. Her exhibitions include a solo show at the Ikon Gallery, Birmingham, 2001, a major survey show at the Centro Cultural Banco do Brazil, Rio de Janeiro, 2002, and the Sao Paolo Biennale 2004.

David Batchelor
Ten Silhouettes

June – October 2005

David Batchelor used ten of the arched niches on the disused platform to house a single work, each a structure made of found steel or aluminium, centrally suspended and illuminated from behind. Viewers could see a series of dark silhouettes of varying sizes and shapes, each surrounded by a halo of colour that filled the alcoves. These works were a continuation and development of a project Batchelor has been working on over the last decade: an examination of the characteristic colours and associated materials of our urban environment, and an attempt to make vivid three-dimensional work from these materials and effects.

Some of the structures were made from items that have been decommissioned from the Underground network and that would otherwise have gone to the scrap heap. The use of found, second-hand objects is one of a number of preoccupations within Batchelor's artistic practice. He has made works using items such as industrial trolleys and steel shelving to discarded road signs,

commercial light-boxes and polyurethane bottles. The pervasive yet indescribable nature of colour, monochrome in particular, is also a key focus for Batchelor, along with a fascination with the urban experience that firmly places the city as a central frame of reference in all of his work. Titles such as *The Spectrum of Hackney Road*, a series of works from 2003, relate directly to specific places in the city of London.

David Batchelor was born in 1955 in Dundee, Scotland, and now works as an artist and writer in London. He is currently a tutor at the Royal College of Art. He has shown work internationally including the 26th São Paulo Biennale, Days Like These at Tate Britain, and Extreme Abstraction at the Albright-Knox Art Gallery in Buffalo.

David Batchelor,
Ten Silhouettes, 2005.
Installation view at
Gloucester Road.
Image courtesy the artist
and London Underground.
Photo: Daisy Hutchison.

Samuel Fosso
Autoportraits

February 2004 – June 2005

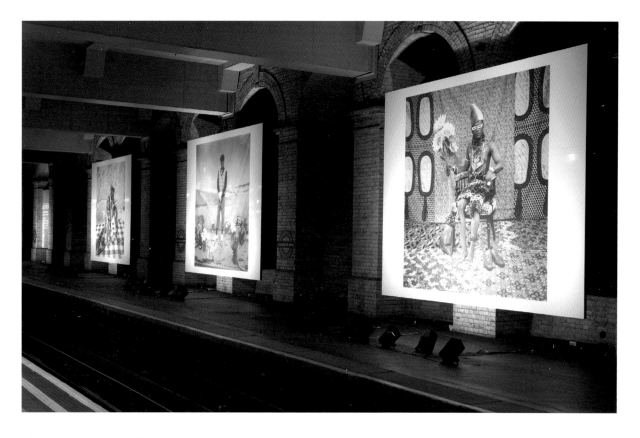

Three works by the Central African artist Samuel Fosso presented in collaboration with London's Hayward Gallery to coincide with its exhibition Africa Remix: Contemporary Art of a Continent.

Samuel Fosso is one of the most renowned of Africa's artists working with photography. In his work he explores a variety of persona and poses, striving to extend his identity by adopting the guise of a number of fictitious roles that are often marked with satire and pathos.

The studio photography genre that has thrived and endured for more than one hundred years in many commercial centres of West Africa has had a strong influence on Fosso's work. His artistic practice developed whilst working out of his small studio producing and selling portraits for the local domestic market. He is now internationally recognised as one of Africa's most important contemporary artists.

Taking on myriad guises using clothing and backdrops, Fosso has made series of fantastical self-portraits, based on a range of characters, from African Chiefs to American women. The works are a witty and ironic exploration of self-identity and he is considered to be one of the first African artists to build a commentary on contemporary African masculinity, gender, identity and sexuality.

Samuel Fosso is one of the most renowned and prodigious young African photographers. His work has been shown in major international venues, such as the Photographers' Gallery in London and the Guggenheim Museum in New York. Born in Cameroon in 1962, he lives and works in Bangui, Central African Republic.

Samuel Fosso, *Autoportraits*, 2005. Installation view at Gloucester Road. Image courtesy the artist and London Underground. Photo: Stephen White.

Paola Pivi
To Me

November 2004 – February 2005

This exhibition comprised three enormous and beautiful images of zebras standing in a landscape of mountains and snow installed on the disused platform at Gloucester Road station. A panorama of snow capped peaks is an incongruous setting for a pair of zebras, animals that we are more accustomed to see grazing the savannahs of Africa. Their stripes are reinforced against the white, making them conspicuous rather than camouflaged. The striking, disconcerting result is in startling contrast to the profoundly urban environment of an Underground train station.

To make these images, Pivi transported two zebras to the Italian National Park of Velino Sirente to be photographed against the backdrop of the mountains there. The work is one of several that she has produced where animals are pictured in unexpected places. A donkey riding in a small boat was the focus of one earlier image. It was reproduced banner size and hung high on the side of a building in Venice for the Venice Biennale, 2003 and at Brown University, Providence, Rhode Island, USA in 2004.

Paola Pivi's projects arise out of fleeting ideas that she realises through a process of organising and performing a vast range of tasks. The end results, whether photographs or works in other media, often place the familiar in unlikely combinations to reveal something absurd, enigmatic or humorous but frequently beautiful.

Paola Pivi was born in Milan and currently lives and works in Anchorage, Alaska.

Lars Arrhenius
A–Z

July – October 2004

Against the background of the classic A–Z style London street guide, Swedish artist, Lars Arrhenius has created an intricate web of narratives comprising 18 characters in scenarios that evolve through more than 250 illustrations. These stories traverse and intersect across the map horizontally, vertically and diagonally in a formation reminiscent of the Underground network. From the tragic to the romantic, the absurd to the cynical, these stories encapsulate the complexity of the city in a fresh visual language. Lars Arrhenius reworked A–Z to appear as ten giant billboards at Gloucester Road station. Arrhenius originally made A–Z as a large-scale limited edition artwork. This was shown at PEER in 2002 who also produced it as a book that borrowed its design from the London street guide. Like the original, Arrhenius' book adopts a non-linear grid reference format. The effect of this for the reader – like when planning or negotiating a journey – is that the fragmented nature of the city becomes emphasised.

Lars Arrhenius was born in Stockholm in 1966. He lives and works in Amsterdam and Stockholm.

Lars Arrhenius,
A–Z, 2004.
Art work for installation
at Gloucester Road.
Image courtesy the artist.

David Shrigley
Billboard Commission

September 2003 – January 2004

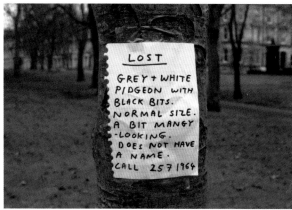

Ten photographs were selected from Shrigley's recent works. They are records of small interventions that the artist performed in various everyday situations. The resulting images have a tone that sits somewhere between the whimsical and the philosophical.

Shrigley's work is for people who laugh at the crises and little tragedies of everyday life or the limits of daily routines. He makes fun of things that you could get depressed about and engages with the everyday doubts and fears of the human condition, articulating odd moral dilemmas with black humour and wit.

Shrigley's drawings, which combine a cartoon-like style with a dark, dry humour, have become well known to audiences both in the UK and internationally.

David Shrigley was born in 1968 in Macclesfield. He lives and works in Glasgow. He attended City of Leicester Polytechnic's Art and Design course in 1987–1988, and subsequently studied at Glasgow School of Art from 1988–1991. He is the author of several books and his work is exhibited throughout the world.

David Shrigley,
Four of ten photographs shown at Gloucester Road, 2003.
Images courtesy the artist and Stephen Friedman Gallery.

Mark Titchner
I WE IT

January – April 2004

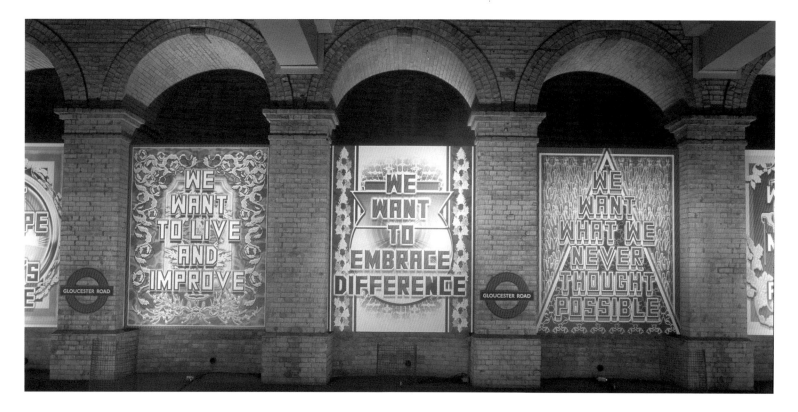

Titchner's project explored billboards or hoardings as a traditional site for advertising or campaigning. In making each work he extracted a single phrase from the corporate vision of each of the world's top ten brands, as they were published in a randomly selected week. The statements were Utopian, almost evangelical, and proposed a model of harmony between mankind, environment, industry and global marketing. The extracts were combined with the prefix "We Want", taken from the ten point plan of an anti-capitalist revolutionary group. Through the addition of these two small words Titchner transformed statements that imply good intentions into demands that seem almost threatening.

Each text was embedded in, and almost overpowered by, a highly stylised background that references the style of trade union banners as well as the designs of William Morris.

Titchner has maintained an interest in these sources particularly because of the relationship they have with traditional craft and the labour movement. Other important references within the works include Baroque religious art as well as psychedelic posters whilst further unmistakable connotations, whether religious, political or corporate, lie in the use of the ten specific demands or commands. The combination of this complex set of references offers a kind of secular spiritual aesthetic. The result is a delicious overload of style, colour and meaning working simultaneously in conflict and in harmony.

Mark Titchner was born in Luton in 1973. He graduated from Central Saint Martins College of Art and Design, London, in 1995. Recently he was nominated for the Turner Prize and appeared in the Ukrainian Pavilion of the Venice Biennale 2007.

Mark Titchner,
I WE IT, 2004.
Above: Installation view
at Gloucester Road.
Opposite: Artwork for
one panel from the series.
Images Courtesy the artist
and London Underground.
Photo: Stephen White.

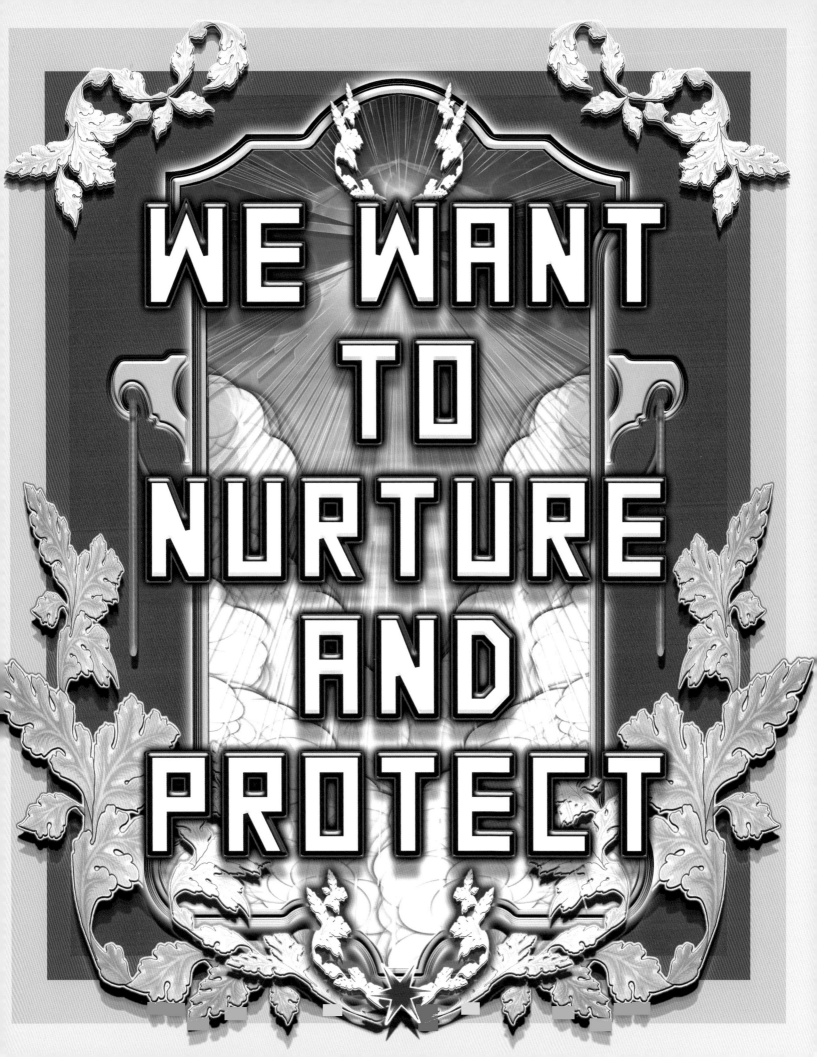

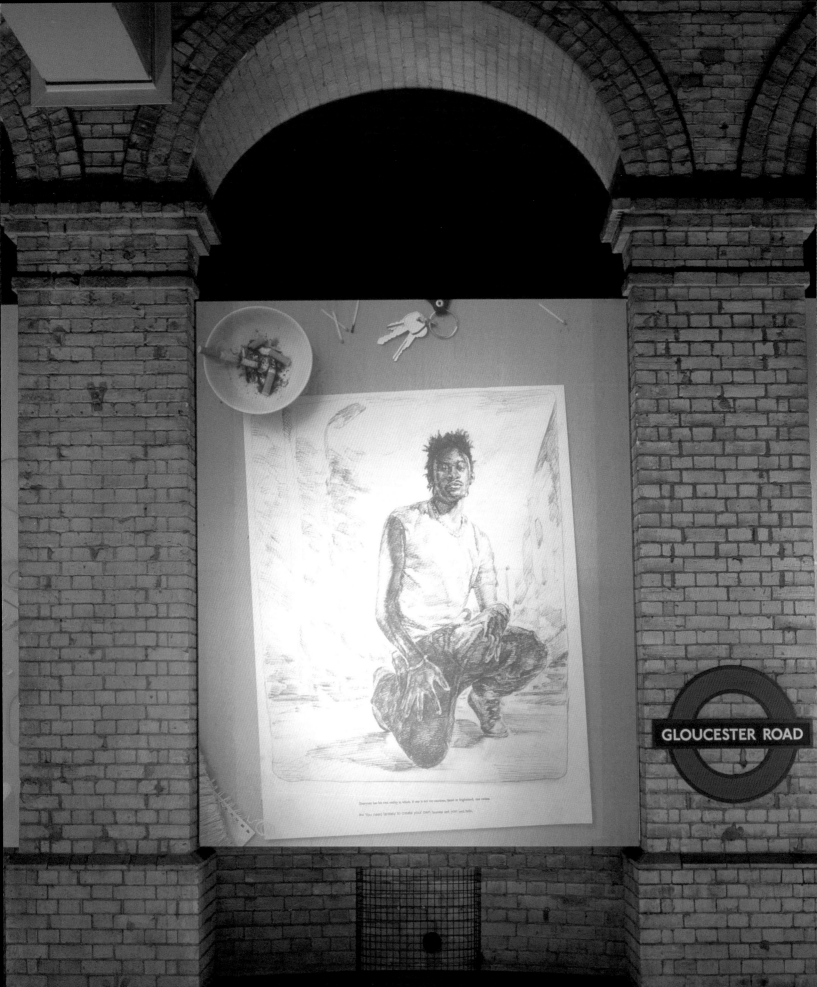

Muntean/Rosenblum
It is Never Facts that Tell

April – July 2004

Muntean/Rosenblum, *It is Never Facts that Tell*, 2004. Above: Installation view at the Tate Britain. Photo: Mark Heathcote, Tate Photography. Opposite: Detail of installation at Gloucester Road. Images Courtesy the artists and London Underground. Photo: Stephen White.

Muntean/Rosenblum have worked together since 1992. Consistently featuring in their work are generic adolescent figures, which are initially appropriated from lifestyle and fashion magazines but then undergo a whole process of transformation and construction. These young, beautiful people are depicted in drawings, paintings or photographs, alone or in groups, in various urban or interior settings. Words and phrases, culled from similar sources, are also carefully placed in the works as if as captions for the images. However, the relationship between image and text is not obvious, raising further questions rather than reinforcing a specific message.

Muntean/Rosenblum's work, in its reference to classical, particularly devotional and allegorical, painting, brings the motifs and emblems of Christian iconography to bear on contemporary characters and situations.

The figures could either communicate pathos, reminiscent of characters from Renaissance paintings undergoing a sublime religious experience or they could simply be bored, a symbol of contemporary ennui. Similarly the disjointed phrases could speak of aspiration and promise, or they could offer notions of doubt and misunderstanding. In keeping with the deliberate uncertainty of meaning in their work, Muntean/Rosenblum question the notion of authorship by working in partnership to create a joint signature style.

The exhibition at Gloucester Road comprised ten billboard-sized photographs of new drawings in a mise-en-scène that includes a variety of personal effects to suggest a private space; it could even be the floor of the artists' studio. The works were commissioned in tandem with an exhibition at Tate Britain.

Markus Muntean was born in 1962 in Graz, Austria; Adi Rosenblum was born in 1962 in Haifa, Israel. They are based in Vienna. They have been working in collaboration since 1992 and have shown widely both in the UK and internationally.

Cindy Sherman
Billboard Commission

June – September 2003

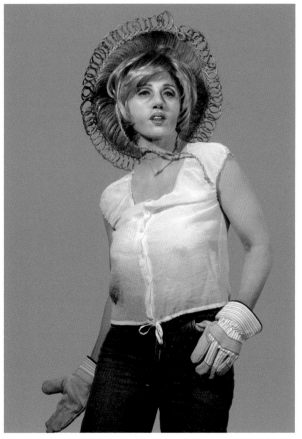

Cindy Sherman made ten large-scale photographs for Gloucester Road Underground station, in the first joint commission by London Underground and the Serpentine Gallery. Timed to coincide with an exhibition of her work at the Serpentine Gallery, this was Sherman's first billboard project.

The Billboard Commission images comprise specially produced versions of works made between 1983 and 2002. Since the mid-1970s Sherman has been taking photographs of herself, combining the roles of model and photographer to create provocative and intriguing works of art. Adopting an array of roles and disguises, she explores and exposes well-defined images and stereotypes of women in Western society and throughout history.

The ten large-scale photographs were specially chosen and rendered by the artist to comprise highly diverse and creative works spanning over the past two decades of Cindy Sherman's career.

Cindy Sherman was born in 1954 in Glen Ridge, New Jersey. She works as a photographer and film director known for her conceptual self-portraits. Sherman currently lives and works in New York.

Cindy Sherman,
Billboard Commission, 2003.
Individual panels from the
series for Gloucester Road.
Images courtesy the artist.

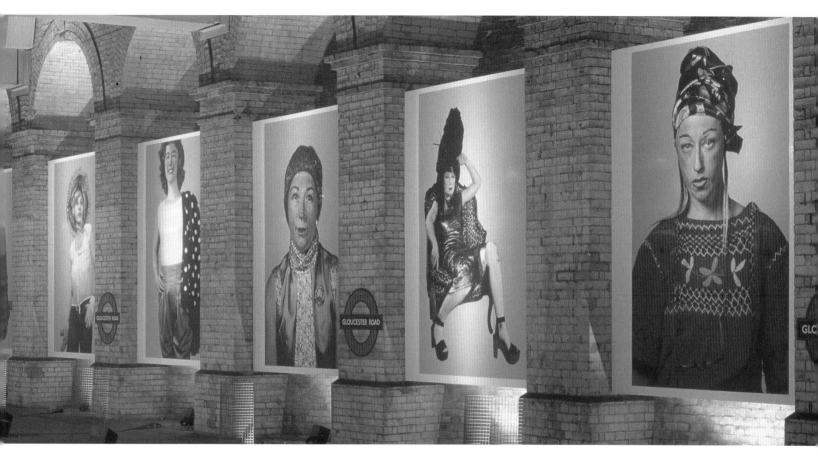

Her work has won her an international reputation as one of the best artists working in the world today. In addition to numerous group exhibitions, her work was the subject of solo exhibitions at the Stedelijk Museum, Amsterdam, in 1982 and the Whitney Museum of American Art, New York, in 1987. A retrospective organized by the Museum Boymans-van Beuningen, Rotterdam, traveled throughout Europe in 1996 and 1997.

Cindy Sherman,
Billboard Commission, 2003.
Installation view at
Gloucester Road.
Images courtesy the artist
and London Underground.
Photo: Stephen White.

PICCADILLY CIRCUS

Lothar Götz
All Day Long

September – December 2006

For this commission, Götz took inspiration from the architecture and signage of the original ticket hall design. In response, *All Day Long* consisted of 22 geometric colour 'blocks' for installation in the former display windows lining the ticket hall – with shapes and colours referring to the colours of the Underground, the everyday life in the station and to the radical modernist thinking behind its design. The bright colours and geometric shapes filled the rectangular windows to create one large-scale, rhythmic work, reminiscent of the constant movement and flow within the ticket hall.

Lothar Götz makes artworks in both interior spaces and on the outside of buildings, creating expanses of vivid colour in either bands or other geometric shapes. These minimalist designs are made specifically for the spaces they occupy, and highlight architectural features and details that would otherwise go unnoticed. He challenges the boundaries that exist between painting, architecture, sculpture, design and decoration.

He has produced his work in many different kinds of spaces, both private and public – from domestic flats and offices to churches and schools.

Götz uses colour to define the architectural qualities and spirit of a space and is interested in the way decoration and colour can have an immediate impact on us, exploring how different shapes, dimensions and colours can influence the way we think, feel, and behave. He is inspired not only by Modernism and Minimalism, but also Bavarian Baroque churches, Renaissance paintings and the architecture of all periods.

Lothar Götz was born in Germany in 1963 and studied in Wuppertal and Düsseldorf, followed by an MA at the Royal College of Art, London. He has exhibited internationally as well as having solo shows in London at The Economist Plaza, Chisenhale Gallery and Gasworks.

Lothar Götz,
All Day Long, 2006.
Above: Artist's sketch
for vinyl panels.
Opposite: Installation view
at Piccadilly Circus.
Images courtesy the artist
and London Underground.
Photo: Michael Franke.

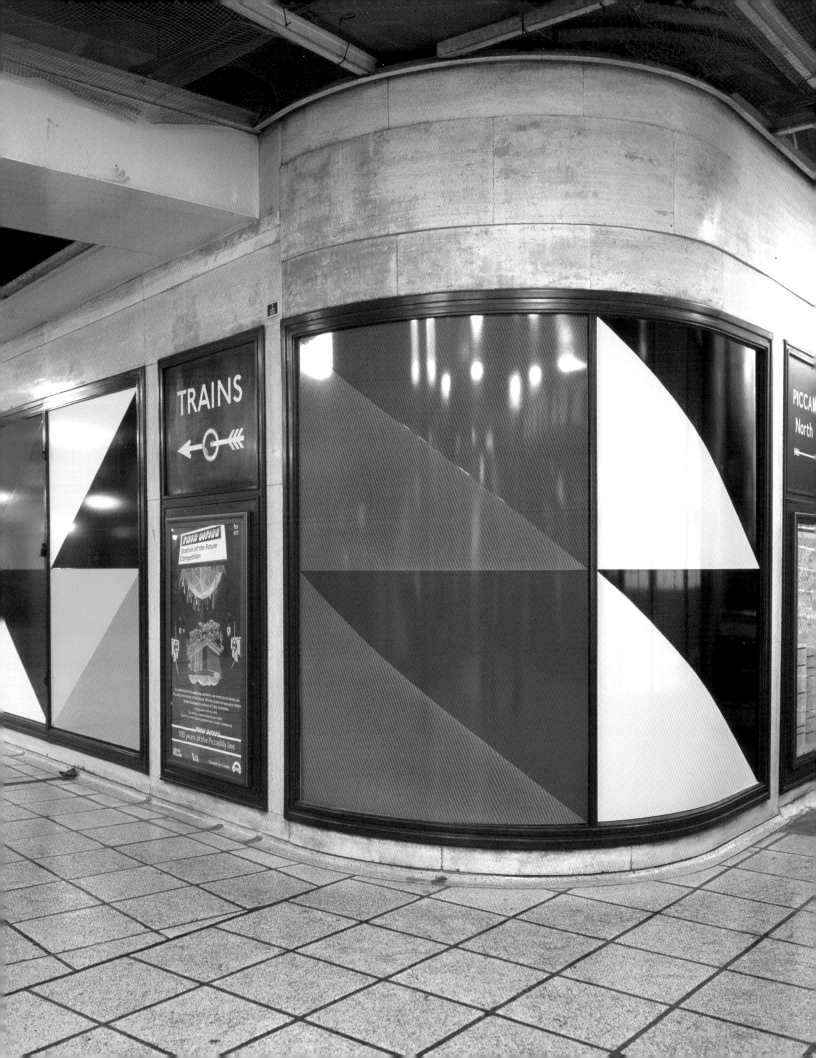

Royal Academy Schools
Line-Up

June – September 2006

Work by five artists graduating from the Royal Academy Schools in 2006: Maisie Kendall, Liane Lang, Robert Rush, Sinta Tantra and Amy Woolley.

A mixture of abstract and figurative work using photography, painting and printing. Maisie Kendall's paintings combine a delicate, multi-layered technique with an inventive and energetic instinct for colour. Liane Lang's large-scale photographs are staged scenes featuring figures that appear life-like but are actually created from latex and foam rubber. Robert Rush samples styles of painting from the past and present, both figurative and abstract. He takes his inspiration from art, design, decoration and other cultural references, such as the language of cartoons. Sinta Tantra combines colourful hand-cut forms made from vinyl, painted shapes and delicate wall drawings to produce chaotic yet captivating images. Amy Woolley's work combines sculpted and readymade objects in scenarios which suggest that they have identities and personalities.

Royal Academy Schools, *Line-Up*, 2006. Detail Robert Rush. Installation view at Piccadilly Circus. Image courtesy the artists and London Underground. Photo: Stephen White.

Beth Derbyshire
Careless Talk Costs Lives

January – June 2006

Beth Derbyshire,
*Careless Talk Costs
Lives*, 2006.
Installation view at
Piccadilly Circus.
Image courtesy the artist
and London Underground.
Photo: Stephen White.

Images featuring hybrid versions of military medal designs fused into decorative backgrounds composed of patterns based on the flora associated with war and remembrance. Embedded within these images are slogans lifted from World War II propaganda posters, including the well known campaign "Careless Talk Costs Lives". Beth Derbyshire's work is inspired by communication and language systems, examining notions of collective identity, individuality and citizenship.

Beth Derbyshire was born in Northampton in 1971 and lives and works in London. Since obtaining an MA from Chelsea in 1996, she has exhibited her work in London, Peterborough, Norwich, Milan, Berlin and Tokyo, including the Sharjah Biennale, 2003, Brussels Art Fair, 2004 and Arco, Madrid, 2005.

Shezad Dawood
The World as Will and Idea

October 2005 – January 2006

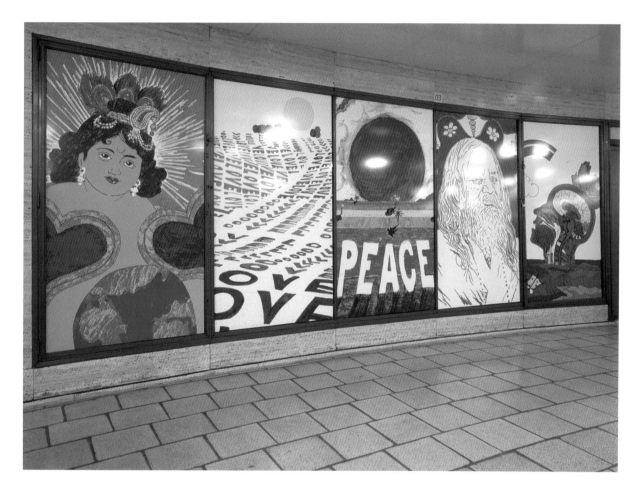

This project was a selection of works from a series of 52 drawings made over 52 weeks. One drawing was produced each week for an entire year making a kind of diary. The ritualistic manner of their production echoes their subject matter, the currency of popular spiritual symbolism. Packed with symbols, signs and images of faith from secular and religious contexts, the drawings are obscure and familiar, mysterious yet recognisable.

As they draw on a wide range of references to different cultures, styles and periods, their meanings are transformed, reflecting a fascination with the search for spiritual value and fulfilment in an increasingly impersonal society. Each image has a charmingly Utopian appeal reminiscent of psychedelic posters produced during the heyday of peace and love in the 1960s. They resemble design classics of spirituality, nostalgically revived as an alternative set of brands for today's consumer lifestyles. The presentation of the works in a busy West End Underground station placed them in the world of high impact advertising.

Shezad Dawood was born in London in 1974 and still lives and works in the city. He graduated with an MA from the Royal College of Art in 2000 and has exhibited in many solo and group shows in the UK and internationally. His work reflects a keen cultural awareness, appropriating various forms of popular image-making and exploring the artist's own sense of cultural hybridity.

Shezad Dawood,
The World as Will and Idea, 2005.
Installation view at Piccadilly Circus.
Image courtesy the artist and London Underground.
Photo: Stephen White.

Royal Academy Schools
Graduating 5

June – September 2005

An exhibition of work by five artists graduating from the Royal Academy Schools in 2005 – Divyesh Bhanderi, Julio Brujis, Sara Gilbert, Emma Jamieson and Ruth Todhunter. The exhibition coincided with the Royal Academy Schools final show in June.

Divyesh Bhanderi produces large-scale drawings through systems that use custom-made spirograph tools. Julio Brujis uses digital technology to manipulate photographic images. He is particularly interested in the illusionary nature of the historical representation of landscape. Sara Gilbert's collection of hand carved objects incorporate motifs and details borrowed from hand-tools, children's toys and many other cultural and social symbols. Emma Jamieson has produced a storyboard of stills from a video/film work. The film focuses on small, evocative moments, fleetingly remembered fragments of a story, an event or a thought imbued with a sense of nostalgia. Ruth Todhunter selects functional objects from the familiar realm of the domestic and the industrial to make abstract photographic compositions about light, colour, texture and shape.

Royal Academy Schools, *Graduating 5*, 2005. Detail Divyesh Bhanderi. Installation view at Piccadilly Circus. Image courtesy the artists and London Underground. Photo: Stephen White.

Anthony Gross
Digital Forest

March – June 2005

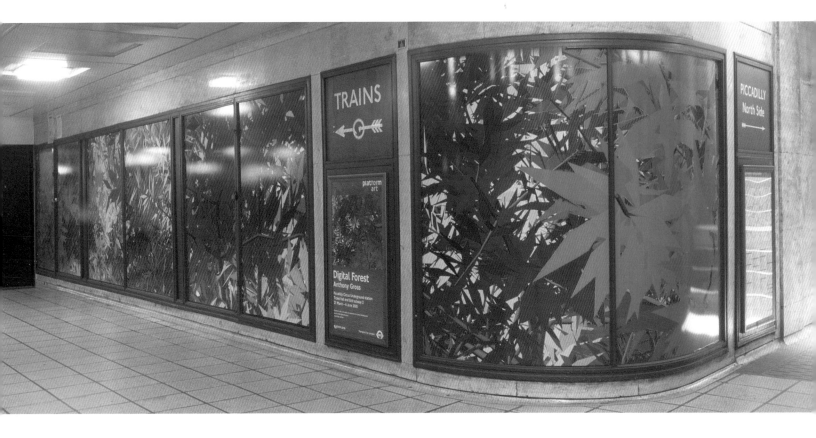

Anthony Gross, featured a digitally rendered forest made up of dense, leafy trees in a rainbow wash of colour. *Digital Forest* was entirely made on computer, constructed by combining dozens of digital trees. The branches and leaves are like digital code, thousands of polygons connected in three-dimensional structures. The the effect is a dense layering of bold colours revealing the crisp coloured shapes of literally millions of individual leaves.

The installation in the station presented a panorama based on the tradition of the diorama. Similar to those presentations of historical scenes or views of distant countries, the images at Piccadilly Circus presented a landscape that is part familiar, part fantastical and which remains tantalisingly out of reach. Gross' work is a response to our media based society and the affect of digital media on contemporary culture. He draws on references from pop videos, computer games, film and advertising. He often customises ready-made, three-dimensional models sourced from Internet communities. The rendering of a virtual forest vista in Piccadilly Circus, brought an idealised, but clearly artificial, version of a natural landscape into a central London Tube station.

UK born Anthony Gross studied Architecture at The Bartlett School of Architecture, University College London, gaining both a BSc and an MA in Architecture, before completing an MA in Fine Art at Goldsmiths College. He lives and works in London and has shown widely in group and solo exhibitions in London, as well as other national and international venues. He is also co-founder and curator of artist run space Temporary Contemporary, an independent project space in South East London.

Anthony Gross,
Digital Forest, 2005.
Installation view,
Piccadilly Circus.
Image courtesy the artist
and London Underground.
Photo: Stephen White.

Ellie Harrison
Gold Card Adventures

January – March 2005

Ellie Harrsion,
Gold Card Adventures, 2005.
Installation view at
Piccadilly Circus.
Image courtesy the artist
and London Underground.
Photo: Stephen White.

The works in the exhibition arose out of a year-long project about the artist's journeys across London using Tubes, trains and buses.

From September 2002 to September 2003, Harrison made a daily commute between her home in Ealing, West London and New Cross in South East London where she was studying for her Postgraduate Diploma in Fine Art at Goldsmiths College. She purchased a Gold Card (year travel pass) to make these journeys and was determined to get more value out her hours spent commuting. She kept a careful record of all of the journeys that she made, calculated the cumulative distance and began marking stages of the ongoing journey as if they were visits to target destinations all around the world.

The project developed into an imaginary challenge to visit as many places as possible. Harrison began to collect postcards from these places purely as a record of their distance from London.

The final work was a series of posters presenting mock postcards from an exciting range of target destinations, with a note of the distances reached en route. The posters were placed in sites in Piccadilly Circus station ticket hall. *Gold Card Adventures* raises questions around local and global travel in the twenty-first century by considering the meaning of distance and the possibility of seeing the world without even leaving the city.

Ellie Harrison is a multi-media artist based in Nottingham.

Henna Nadeem
Trees, Water, Rocks

October 2004 – January 2005

Henna Nadeem's exhibition brought images of spectacular natural landscapes from a range of continents such as Africa, America and Australia right into the centre of London's metropolis. Each image is a combination of several, selected directly from books and magazines and united by collaging them together in carefully cut intricate designs.

In her previous work Nadeem has gathered patterns and motifs largely from Islamic cultures. These new works also borrow from Islamic designs but include references from other cultural sources as well. There are Japanese and Moorish motifs for example, and these clearly stand out whilst others have a less easily identifiable origin. Some images are the result of a blend of many different patterns. This integration seems apt in a site that people from the world's vast range of countries and cultures pass through on a daily basis.

Nadeem has perfected her collage technique to a degree that makes the physical cutting and gluing process almost impossible to notice. However, these new works have undergone the further process of being digitally scanned and enlarged to several times the original size. Some of her patterned landscapes are now up to six metres long; stretching across several panels in the station. This is the first time Nadeem's work has been seen on such a scale, where the careful cuts she has made by scalpel become revealed, and we can more easily imagine the painstaking process undertaken to produce these works.

Henna Nadeem was born in 1966 in Leeds. She graduated from the Royal College of Art in 1993 and lives and works in London.

Henna Nadeem,
Trees, Water, Rocks, 2005.
Installation view at
Piccadilly Circus.
Image courtesy the artist
and London Underground.
Photo: Stephen White.

Zhao Bandi
Uh-oh! Pandaman

July – October 2004

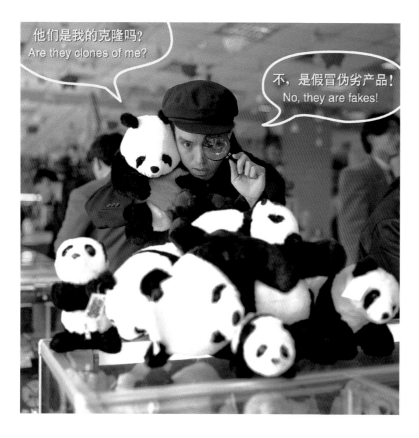

The Beijing based artist Zhao Bandi creates photographs of himself and his toy panda in a range of situations. Their 'speech bubble' conversations, delivered with deadpan humour, consider a variety of issues facing contemporary society. Bandi's photographic works draw on the language of advertising and of public service information and he often uses similar locations to exhibit his work. By presenting his images on these sites he reaches mass audiences with his creative messages.

The panda is the artist's companion and a symbol of China's one-child policy and the messages in these works often parody Chinese state propaganda. Zhao Bandi explores the most irrational and absurd aspects of certain ideological campaigns that are still quite common in China. He also aims for a sense of displacement: the toy panda, the artist's clothing, his expression, the setting and the

dialogues are all carefully measured expressions of a very personal sense of humour.

The exhibition in Piccadilly Circus Underground station was a combination of images from several series of works made between 1996 and 2003 and was part of the largest public exhibition of Zhao Bandi's work outside of China, showing simultaneously in four cities throughout the summer. Manchester Art Gallery, the Ikon Gallery in Birmingham and the Aspex Gallery in Portsmouth in association with the Red Mansion Foundation and Platform for Art, collaborated to present Zhao Bandi's work in a series of off-site shows and gallery-based exhibitions.

Zhao Bandi was born in Beijing and graduated from the Central Academy of Fine Arts, Oil Painting Department, Beijing. He lives and works in Beijing.

Zhao Bandi,
Uh-oh! Pandaman, 2004.
Image for installation
at Piccadilly Circus.
Image courtesy the artist.

Simon Bedwell
Advertising Never Tells Anyone Anything Anyway

April – July 2004

Simon Bedwell, one of ten artists shortlisted for Beck's Futures 2004, created four sets of posters specifically for Piccadilly Circus station. Using ClipArt and WordArt software, available to almost anybody with a computer, Bedwell's posters combine found pictures with words and phrases, real and invented. As in much of his work, a wide range of visual material, from promotional blurbs to local newspaper headlines, from 1950s photography to Communist Bloc advertising, combines to shape the final images.

The project was a collaboration between Platform for Art and the Institute of Contemporary Arts, made to coincide with Beck's Futures 2004, the annual exhibition and awards for contemporary artists.

Simon Bedwell was born in 1963 in Croydon, UK. From 1991–2002 he worked almost exclusively under the name BANK, a studio-based collaborative practice. Since 2003 he has been working as a solo artist. He currently lives and works in London.

Simon Bedwell,
*Advertising Never
Tells Anyone Anything
Anyway*, 2004.
Installation view at
Piccadilly Circus.
Image courtesy the artist
and London Underground.
Photo: Stephen White.

Janette Parris
Going South

September 2003 – February 2004

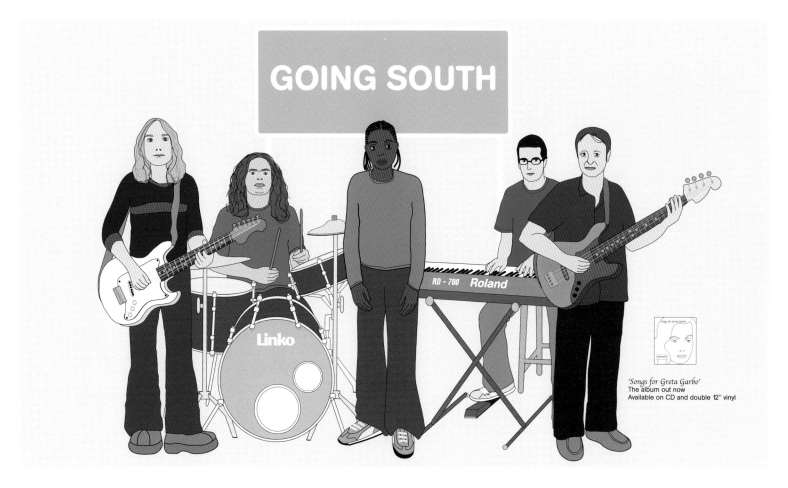

'Songs for Greta Garbo'
The album out now
Available on CD and double 12" vinyl

Janette Paris,
Going South, 2004.
Artwork for installation
at Piccadilly Circus.
Image courtesy the artist.

Parris produced cartoon style drawings of the individual members of a fictional pop band. The images take Piccadilly Circus station's proximity to the famous Tower Records as a starting point. They are bright and colourful yet the characters, like those in many of Parris' previous work, appear rather ordinary, unlike the glamorous images of the traditional pop star.

Janette Parris uses everyday people as the basis for much of her work. The works produced for Piccadilly Circus reflect the pathos behind everybody's desire to become successful and well known. Despite the pop star status of the characters the artist has drawn, they still fail to stand out from the crowd. The drawings capture the comic yet tragic truth that to become a celebrity doesn't make an individual fundamentally any different from everybody else.

Parris consistently takes a dry, self-effacing look at the world and the way that we are all performers within it. Her work captures the humorous essence of life but always notes the sharp melancholic edge that goes with it.

Jannette Parris was born in London in 1962. She studied at Camberwell College of Art until 1991, and at Goldsmiths College, London until 1994, where she received an MA in Fine Art.

Eileen Perrier
Grace

January – March 2002

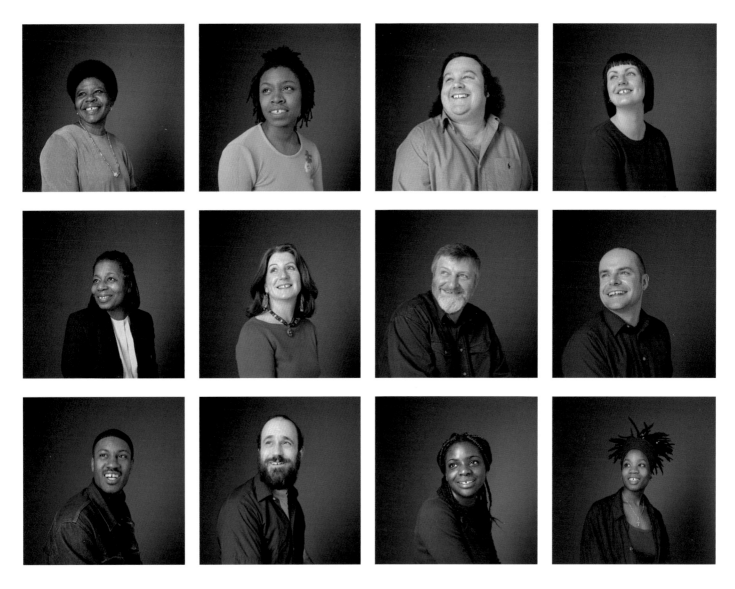

This project presented photographs from a series of portraits the artist has made of individuals who all have a gap between their two front teeth. Eileen Perrier has a gap between her own front teeth and this was the starting point of her project. She seated each of her subjects in the same position looking in the same direction in a reference to how as school children many people have similar portraits taken annually. Perrier's work relates to racial and cultural stereotypes and differences. She selects seemingly innocuous features that link a range of people from a range of cultural backgrounds. She sees this series of works as a celebration of subtle difference – even those for which people are mocked – particularly as children.

Eileen Perrier was born in 1974 in London. She received an MA from the Royal College of Fine Art in 2000 which was preceded by a BA at the Surrey Institute of Art and Design.

Eileen Perrier,
Grace, 2002.
Artwork for installation
at Piccadilly Circus.
Images courtesy the artist.

Paul Catherall
London Linos

April – May 2002

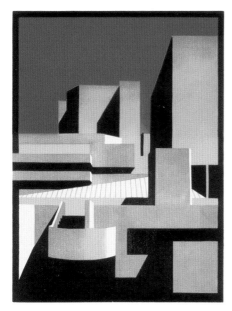
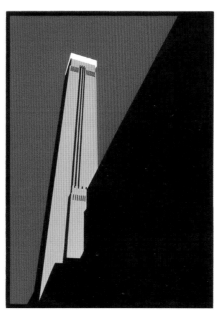

Paul Catherall,
London Linos, 2002.
Artwork for installation
at Piccadilly Circus.
Images courtesy the artist.

Paul Catherall presented a series of posters reproduced from linocuts for Piccadilly Circus. The artist has become well known for his depictions of London landmarks. Using a clean, sharp palette inspired by commercial art from the 1930s to the 1960s, his images read as a contemporary identity of London through its current skyline. Linocuts are a traditional form of relief printmaking. Sections are cut away from a lino block and ink is applied to the remaining surface areas. This is then printed directly on to the paper using the lightest tone first.

TUBE MAPS

Cornelia Parker
Underground Abstract

January 2008

Cornelia Parker's artwork is based on Rorschach drawings used by psychoanalysts to understand patients' psychological and emotional associations with visual imagery.

Taking a section of the famous Beck map, Parker has reproduced it from memory in coloured paint – with a nod in the direction of David Booth's *The Tate Gallery By Tube* poster showing the London Underground lines drawn out in Tubes of paint'.

This paint 'drawing' was then folded in half to create a symmetrical imprint creating a new symbol for the front cover. By association viewers will begin to see many other forms within this new network of colours in a similar manner to the public's popularisation of the map. Over the years passengers have whiled away many a journey seeing other shapes and forms in Beck's visionary image.

For some years Cornelia Parker's work has been concerned with formalising things beyond our control. She is fascinated with processes in the world that mimic cartoon 'deaths' – steamrollering, shooting full of holes, falling from cliffs and explosions. Through a combination of visual and verbal allusions, her work triggers cultural metaphors and personal associations which allow the viewer to witness the transformation of the most ordinary objects into something compelling and extraordinary.

Cornelia Parker was born in Cheshire in 1956 and studied at Wolverhampton Polytechnic and Reading University. She has exhibited widely in the UK and internationally and was a Turner prize nominee in 1997. One of her best known works, *Cold Dark Matter: An Exploded View*, 1991, is now part of the Tate Collection. She lives and works in London.

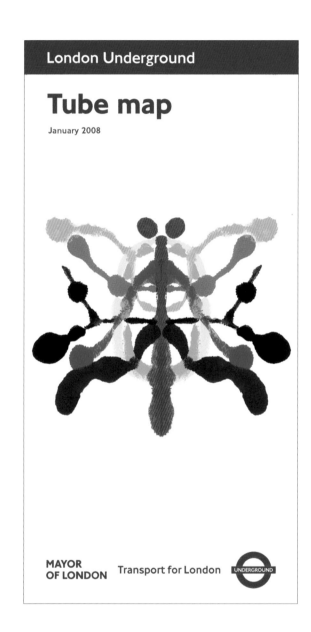

Cornelia Parker,
Underground Abstract,
November 2007.
Pocket Tube map cover.
© Transport for London.

Jeremy Deller
Portrait of John Hough (Transport for London's longest serving member of staff – 45 years of service)

July – November 2007

Portrait of John Hough was the first pictorial image to feature on the front of the Pocket Tube Map showing a delicate line drawing of John Hough who at the time was the longest serving member of operational staff working for Transport for London. It metaphorically re-inserted the human face of the organisation back into the public realm in a time when staff are slowly being replaced by digital systems. The work draws associations between Harry Beck's famous diagram of the network and the idea of a portrait as an alternative, more literal face of the organisation. In a manner typical to Deller's practice the work was a collaboration with another artist. Paul Ryan, an established artist in his own right, produced the line drawing and translated it into the colours of the map in accordance with the developing tradition of the artwork.

Jeremy Deller was born 1966 in London. He won the Turner Prize in 2004 and is best known for his work *The Battle of Orgreave* in which several re-enactment societies restaged a battle which occurred between police and miners in the 1980s.

Paul Ryan was born in 1968 in Leicester and is currently completing a PHD at Wimbledon School of Art and Design and has exhibited widely throughout the UK. He lives and works in London.

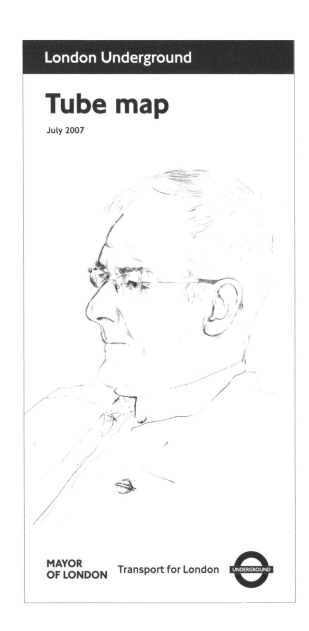

Jeremy Deller with Paul Ryan,
*Portrait of John Hough
(Longest Serving Member of
Transport for London Staff.
45 year's service)*, 2006.
Pocket Tube map cover,
July 2007.
© Transport for London.

Liam Gillick
The Day Before (You know what they'll call it? They'll call it the Tube)

January 2006 – June 2007

Gillick presented a bold typographic layout of a key date in the history of London Underground. Friday January the ninth eighteen sixty three, was the day before the first ever Tube ran in the capital. By extracting and abstracting this date the work questions the organisation in its entirety somehow suggesting the whole vast network in one short sentence. The artist's use of the colours of the lines in this awkward fashion links to his interest in the importance and symbolism of language in everyday life, how we consume it almost unquestioningly and how it in return controls our daily experiences. The colours perform their opposite function breaking up the words in uncomfortable patterns interrupting the visual flow of the sentence in a manner contradictory to their use within the map where they elegantly symbolise whole tracts of the city.

Liam Gillick was born in 1964 in Aylesbury, Buckinghamshire. He studied at Goldsmiths College, University of London from 1984–1987. He lives and works in London and New York. In 2002 Gillick was a Turner Prize finalist and had a major solo exhibition, The Wood Way, at the Whitechapel Art Gallery. He has since, amongst many other projects, been commissioned to make a permanent work at The Home Office, London.

London Underground

Tube map

May 2007

**fridayjanu
arythenint
heighteen
sixtythree.**

MAYOR OF LONDON Transport for London UNDERGROUND

Liam Gillick,
The Day Before (You know what they'll call it? They'll call it the Tube), 2007.
Pocket Tube map cover January 2007.
© Transport for London

Yinka Shonibare
Global Underground Map

June 2006 – November 2007

Shonibare's Tube Map cover depicts a map of the World drawn by hand employing the colours of the Tube map to reflect the diversity of London and the users of London Underground. The countries of the world were given a subtle shift of identity by implying new relationships based on the colours of the Tube lines. The landmasses of the world were divided into a patchwork by superimposing an invisible grid similar to those created by the lines of latitude and longitude which appear on conventional maps. This metaphorical patchwork also refers to pieces the artist produced previously making use of traditional cloth designs from West Africa.

Yinka Shonibare's *Global Underground Map* is the artist's vision of London – and London Underground and its users – as a microcosm of the world. London is a city defined by and celebrated for its identity as a truly multi-cultural and diverse city.

Yinka Shonibare MBE was born and lives in London. He spent much of his early life in Lagos, Nigeria before returning to the UK to study. He graduated from Byam Shaw School of Art, London (now Central Saint Martins School of Art and Design) in 1989 before completing an MA in Fine Art at Goldsmiths College, University of London. He was nominated for the Turner Prize in 2004 for his exhibition Double Dutch at the Museum Boijmans van Beuningen, Rotterdam.

Yinka Shonibare,
*Global Underground
Map*, 2006.
Pocket Tube map
cover, June 2006.
© Transport for London.

David Shrigley
Map of The London Underground

November 2005 – June 2006

Gary Hume

June – November 2005

Shrigley's work, an abstract tangle made up of the coloured lines of the Tube map, immediately references this iconic diagram. In typical Shrigley style, it takes the coloured lines and feeds them through his endlessly imaginative, creative mind and then serves them up as a simple chaotic scribble like a plate of exploding spaghetti. Bright, anarchic and humorous, Shrigley has subverted the reassuring order of the Underground map and turned it into a wriggling, teeming fiesta, echoing the absurd confusion of one of his comic characters when confronted by an extensive travel network.

David Shrigley was born in 1968 in Macclesfield. He lives and works in Glasgow. He attended City of Leicester Polytechnic's Art and Design course in 1987–1988, and subsequently studied at Glasgow School of Art from 1988–1991. He is the author of several books and his work is exhibited throughout the world.

(see page 49)

Hume's work for the Tube map cover, an abstract grid made up of colours that relate to those of the Tube map itself, conjures up a diagram or a map. It also incorporates the famous London Underground roundel, as well as other elements of the Transport for London branding as an integral part of the image.

Gary Hume, born in 1962, was one of the generation of British artists who graduated from Goldsmiths College, London and came to prominence in the early 1990s. He first received critical acclaim with a body of work known as the 'door' paintings. Internationally recognised both in Europe and America, Hume has exhibited extensively around the world. In 1996 he was the British representative at the São Paulo Biennale and in the same year was nominated for the Turner Prize. In 1999 he represented Britain at the Venice Biennale and has also had solo exhibitions at the Bonnefanten Museum, Maastricht, the Scottish National Gallery of Modern Art, Edinburgh, the Whitechapel Art Gallery, London, and Fundació La Caixa, Barcelona.

Emma Kay
You are in London

August 2004

You Are in London by Emma Kay was the first image commissioned for the Tube map cover and was produced in collaboration with Frieze Projects to coincide with Frieze Art Fair 2004. The image is deceptive in its apparent simplicity with its own identity inextricably linked with that of London Underground. It showed a multi-coloured target that playfully combined the Tube line colours with art historical references, graphic design and our collective memory. Kay's concentric circle composition, which exclusively comprises the colours that represent each of the Tube lines, prompts a double-take as we work out why it seems so familiar. Emma Kay's use of a familiar motif – the target – relates this work to many themes. It could suggest that being in London means that you are on target, possibly even at the centre of things! But Kay also wants to remind us of the frequent reoccurrence of the target in the work of other artists: Jasper Johns, Ugo Rondinone and Kenneth Noland, to name but three.

Emma Kay was born in London in 1961, and studied at Goldsmiths College, University of London. She has exhibited widely in the UK, Europe and America. Her work is featured in several high profile public and private collections.

(see page 47)

Gary Hume,
Untitled, 2005.
Pocket Tube map
cover, July 2005.
© Transport for London.

THIN CITIES

Thin Cities

December 2006 – December 2007
Piccadilly line

Thin Cities was a series of new artworks commissioned to appear in sites along the Piccadilly line throughout December 2006 to December 2007. The project was developed as part of celebrations to mark the centenary of the Piccadilly line.

The series of commissions responded to the theme of past, present and future and was inspired by the travels of the fourteenth century explorer Marco Polo, as retold in the book *Invisible Cities* by Italo Calvino. Each artist has engaged with a different aspect of the Piccadilly line and its history, resulting in a site specific group exhibition on a grand scale. As explorers and storytellers themselves, the artists aimed to reveal new perspectives on London through their artworks. An extension to the Platform for Art web pages was developed to accompany *Thin Cities* where people could make a virtual visit to each station on the Piccadilly line and discover something new about its history and the people who live and work along the line.

Visitors to the site were able to leave comments about the work or tell a story or anecdote about the Piccadilly line to be published on the site. A series of limited edition Oyster card wallets were commissioned from selected project artists and were given away to those who responded on the site.

Nils Norman,
Fantasy Piccadilly line, 2007.
Map for all Piccadilly
line trains.
Image courtesy the artist.

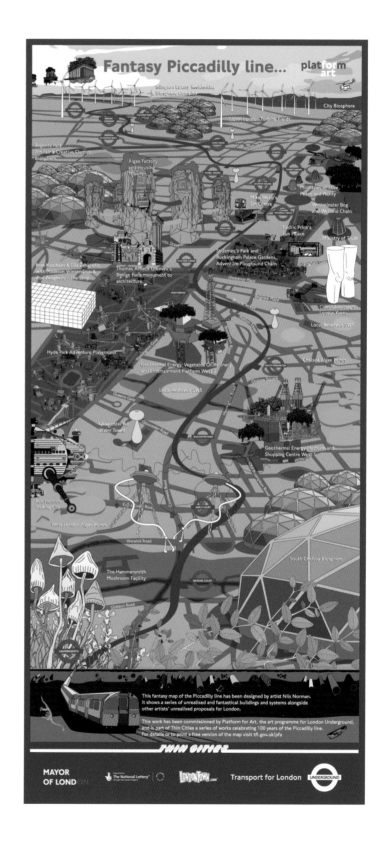

Rut Blees Luxemburg
Piccadilly's Peccadilloes

Heathrow Terminal Four Ticket Hall
July – December 2007

Rut Blees Luxemburg was commissioned to produce a set of new photographs for her contribution to *Thin Cities*. The resulting works – Piccadilly's Peccadilloes – showed details from the fronts of 12 classic Piccadilly line stations designed by Charles Holden. Each image focused on the Underground's iconic Johnston font reflected in glossy-wet surfaces as a motif throughout the series. The word peccadillo means an insignificant mistake or petty misdead, an idea explored through the artist's use of pools of water as a frame through which to examine the distinctive character of some of the Underground's historic stations.

The works extend Blees Luxemburg's interest in the ambitions and unexpected elaborations of the modern project in Britain, seeking moments where layers of history are revealed in architectural form. All of the images were exhibited as 24 large-scale prints that circle the ticket hall at Heathrow Terminal 4 Underground station.

Rut Blees Luxemburg was born in Germany in 1967. She lives and works in London. She studied at the University of Westminster, London from 1990–1993 where she completed an MA in Photography. Prior to this she studied at the London College of Printing for her BA, also in Photography. She has exhibited throughout the UK and Europe and features in prominent public and private collections.

Rut Blees Luxemburg,
Piccadilly's Peccadilloes, 2007.
Park Royal.
Image courtesy the artist.

Jim Isermann
Piccadilly line Tube wrap

April – October 2007

Jim Isermann's design to cover an entire seven carriage Tube train was a key piece in the *Thin Cities* commissions. The work was a subtle reflection on design and architecture styles featured at iconic stations along the Piccadilly line through which the train traveled during the day. The work was two sided in that it used two colour palettes which were reversed on either side of the train. The delicate geometric repeat pattern was designed specifically for this context and responded to the movement of the train and the environment through which it passed. An extension of Isermann's interest in modernist design the train was the first of its kind to be wrapped entirely in an artwork and presented one of the largest mobile artworks. For a limited period the interior of the train was also decorated in Isermann's design. Travelers on the train were encouraged to text in their comments about the work via SMS as they were transported to their destination.

Based in LA, Isermann has exhibited widely around the world in both public contexts and high profile gallery projects such as the Camden Arts Centre, London, and Dietsch Projects, New York. He has successfully translated his aesthetic from the studio and gallery to high profile public contexts including the facade of a New York Subway station. He was born in Kenosha, Wisconsin in 1955, Isermann lives and works in Palm Springs, Los Angeles.

Jim Isermann,
Piccadilly line Tube
wrap, 2007.
Artist's designs.
Image courtesy the artist.

Richard Woods
Logo No. 26

Leicester Square and Green Park
December 2006 – July 2007

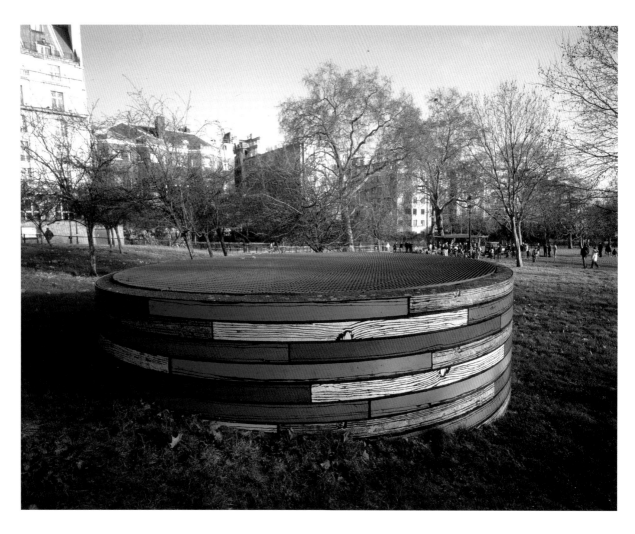

Richard Woods,
Logo No. 26, 2007.
Installation view at
Green Park.
Image courtesy the artist
and London Underground.
Photo: Declan O'Neil.

Richard Woods' *Logo No. 26* was a sculptural installation in two parts. A new, printed 'skin' was applied by Woods to two circular forms at Leicester Square and Green Park stations adding a new hyper-visual language to the architecture.

The artist uses the traditional technique of woodblock printing, carving out large wooden blocks, inking the surface and then printing onto sheets of plywood, MDF or vinyl, but the scale of his oversize prints stretch far beyond any standard frame instead covering entire floors, walls, ceilings and more recently entire buildings.

Applied to the surface of the central Operations Room of Leicester Square the work places the idea of wood back into practice as many kiosks and parts of architecture have gradually had their wooden elements replaced by brass or other non-combustible materials. Outside, in Green Park, the modern concrete air vent of the station is clad in the same juxtaposing and cartoonish design, set against the manicured landscape of the park.

Richard Woods was born in Cheshire in 1966. He graduated from the Slade School of Fine Art in 1998 and has since shown extensively in Britain, Europe, Japan and the USA.

Simon & Tom Bloor
The necessity of everyday living

Arnos Grove
December 2006 – April 2007

For their work *The necessity of everyday living*, artists Simon & Tom Bloor converted the Passimeter at Arnos Grove station into a working artists studio. They spent one week per month for four months at the Passimeter and traveling up and down the line to research material for small publications which would be produced and distributed from the 'studio'. The artists also took material from their research and gradually pasted the outside of the structure with the graphic works as the project progressed, developing a striking visual collage for passers by to enjoy.

The four publications produced were distributed to all Piccadilly line staff. The books took one key figure in the history of the Piccadilly line – Frank Pick, Charles Holden, Tyson Yerkes and Leslie Green – and used them as the focus of their research producing low-fi graphic collages that incorporated slogans and beliefs upheld by each. Simon & Tom Bloor both live and work in Birmingham, UK and were born in 1973. They received BAs from Leeds Metropolitan University in 2000 and have since exhibited widely in the UK and Europe.

Simon & Tom Bloor,
The necessity of everyday living, 2007.
Centre spread of booklet three.
Images courtesy the artists.

Heather & Ivan Morison
Zoorama

Knightsbridge
December 2006 – December 2007

Heather & Ivan Morison,
Zoorama, 2006/2007.
Graphic from station signage
at Knightsbridge.
Image courtesy the artists.

Artists Heather & Ivan Morison created a year-long sound installation for Knightsbridge station in which weekly sound recordings were played over the tannoy system on the platforms and escalators. Each sound recording featured a different animal selected from the British Library sound archives. Animals featured ranged from Hooper swans to an earwig and present a cornucopia of wildlife at the station in contrast with the deeply urban environment.

The artists also produced an individual pod-cast for each recorded animal which could be downloaded from the *Thin Cities* website. The pod-casts included the full archive recording as well as a spoken informational text about each species. The voice for the pod-casts and announcements was that of Emma Ward the 'voice of London Underground'.

Heather & Ivan Morison live and work in Wales. They recently represented Wales at the Venice Biennale and were featured in The British Art Show 6. They have completed a wide range of projects and exhibitions in the UK and internationally, as well as continuing the development of their own arboretum.

Nils Norman
Fantasy Piccadilly line and Ideal City

Laminate maps in all Piccadilly line trains and Piccadilly Circus Ticket Hall installation
April 2007 – December 2007

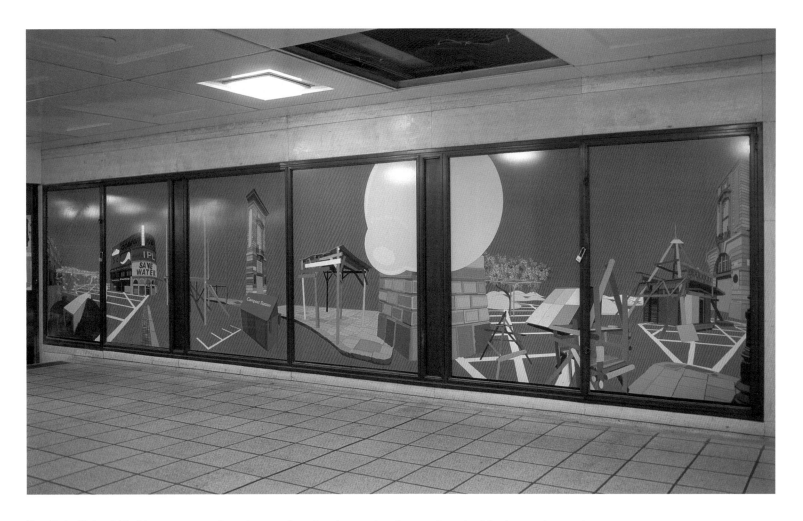

For *Thin Cities* Nils Norman completed two related projects. The first was the development of a new above ground map to be located on every car of every Piccadilly line train opposite the original maps featuring tourist destinations. Norman's version presented alternative architectural and historical features and proposals, some of which were real, others were entirely fictional. The map was called *Fantasy Piccadilly line*.

Ideal City developed along similar lines of interest presenting a large-scale graphic work for the display windows at Piccadilly Circus. The piece featured famous architectural landmarks local to

the station but assigned with alternative perhaps more ecologically minded uses.

Nils Norman was born in Kent, England in 1966. He studied Fine Art Painting BA Hons at Saint Martins School of Art in London. Norman now lives and works in London. Working across the disciplines of public art, architecture and urban planning his projects challenge notions of the function of public art and the efficacy of much urban planning and large-scale regeneration. He writes articles, designs book covers and posters, collaborates with other artists, teaches and lectures in Europe and the US and exhibits in a range of public and commercial contexts.

Nils Norman,
Ideal City, 2007.
Installation view at
Piccadilly Circus.
Image courtesy the artist
and London Underground.
Photo: Andy Keate.

Guy Bar Amotz
New Transport Band

Holiday Inn – Russell Square, Heathrow Terminal Four, Uxbridge, Cockfosters and Arnos Grove
December 2006 – March 2007

Guy Bar Amotz,
*The New Transport
Band*, 2006/2007.
Left – Sharon Gal performing
at Heathrow Terminal 4.
Photo: Declan O'Neil.
Right – Sculptural PA system.
Photo: Kabel.
Images courtesy the artists
and London Transport.

In response to the *Thin Cities* brief Guy Bar Amotz produced a series of live performances in stations across the network using his specially designed sculptural PA system. Cast in black resin the imposing speakers feature the faces of famous musicians whose lives and careers ended in tragedy through drink or excess. The notion behind the work is that new performers from a contemporary era of music and art will perform through the speakers responding to the dead musicians and so forming a moving tribute and scintillating performance for passing audiences. The transient nature of the performance sites meant that for each occasion the audience shifted and ebbed depending on the time of day adding another layer of interpretation to the music being played and the participatory nature of the work. The performers were Fabienne Audeoud, Sharon Gal, Saul Eisenberg, Violet Sometimes, Barnaby Hollington and Alex Cameron. Bar Amotz's project was produced with Chas de Suite.

Guy Bar Amotz was born in Israel in 1967 and works and lives in London. Current and recent solo shows include One In the Other, London in 2005, The Project, Dublin in 2004 and Dance Machine, Tate Britain, London in 2003.

Keith Wilson
Zone 1 (Piccadilly line walkway)

Hammersmith

Keith Wilson was commissioned to make a new work for the ticket hall on the Piccadilly line station concourse at Hammersmith. This large-scale work was designed around the route the Piccadilly line takes through the central zone of the city as represented on Beck's famous map. The serpentine course is re-formed as a person sized walkway made from galvanised sheet metal. Wilson's most renowned works borrow from the language of agricultural architecture examining ideas of proximity and human behaviour by producing confined spaces reminiscent of cattle mobility systems. The works encourage a certain type of interaction from their viewers and produce innate responses through their form and materials.

Wilson was born in Birmingham and studied at Ruskin School of Fine Art, Oxford for his BA before going to the Slade School of Fine Art where he gained his MA. He has exhibited nationally and internationally with recent works being shown at Roche Park in Salisbury as well as Cannizaro Park in Wimbledon, London and more recently he has been commissioned to make permanent works for Canary Wharf and the Wellcome Trust.

Keith Wilson,
Zone 1, (Piccadilly line walkway), 2007.
Artist's impression.
Image courtesy the artist.

Stephen Willats
Assumptions and Presumptions

Rayners Lane and Sudbury Town
October 2007 – December 2007

Stephen Willats,
*Assumptions and
Presumptions*, 2007.
Film stills.
Image courtesy the artist.

The suburban districts of major cities have long been a fascination for artist Stephen Willats. For *Thin Cities* he mined this interest through the making of a new film work based at Rayners Lane and Sudbury Town stations. *Assumptions and Presumptions* presents the two stations and the journey between as a social system in which people are voluntarily confined whilst moving from A to B. Whilst on journeys we inevitably take in our fellow commuters making a myriad judgements about their personalities, occupations and lifestyles. Willats analyses our thought processes as we do so by presenting a film in which normal customers were filmed alongside actors making repeated journeys wearing slightly different clothes each time. As we begin to filter out 'real' people from actors we asses the basis on which we make value judgments about others. The film was presented on two sets of three monitors, one at either station.

Born in 1943, Stephen Willats lives and works in London. He completed 'The Groundcourse' led by Roy Acott at Ealing School of Art in 1963. Willats has enjoyed a long career exhibiting widely in Europe and the UK. Recently he had a solo exhibition at the Milton Keynes Gallery and is represented by Victoria Miro Gallery, London. His work is held in many major public and private collections.

Emma Rushton and Derek Tyman
Piccadillyland

Uxbridge, Cockfosters, Heathrow Terminal 4

Before she left she telephoned Bogdan Lewkovitch and said she wanted to talk to him. He suggested they meet in a café near South Kensington Tube station. He was waiting there when she arrived. It was a dark, old-fashioned-looking place, with cracked oilcloths on the table and run by a staff of stout old ladies. They drank milky coffee from scratched Perspex cups.

Page 224, Brazzaville Beach by William Boyd
Edition: published by Penguin Group, 1990
ISBN 0-14-014658-X
First published in Great Britain
by Sinclair-Stevenson Ltd 1990

I went out to stretch my legs and refuel. It was a fine warm evening. The young swarmed round Leicester Square Tube station as they always do at that time of day, whatever the season. They bubble up from the subway like some irrepressible underground spring, spill out on to the pavement, and stand around outside the Hippodrome in their flimsy casual clothes looking eager and expectant. What are they hoping for? I don't think most of them could tell you if you asked them. Some adventure, some encounter, some miraculous transformation of their ordinary lives.

Page 214, Therapy by David Lodge
Edition: Published in Penguin Books 1996
ISBN 0-14-025358-0
First published by Secker & Wargburg Ltd 1995

Rushton and Tyman responded directly to the literary origins of *Thin Cities*. Looking specifically at how the Piccadilly line has been represented in fictional writing the artist collaborators have collected quotes from a wide range of books referring directly to the line. The quotes were collected together along with three sets of all the books. The books were housed in book-racks at Heathrow Terminal 4, Uxbridge and Cockfosters as public reading rooms for waiting passengers at the ends of the line. The quotes were brought together into a new publication creating a new text from the individual lines. Copies of these booklets were inserted into the book-racks for customers to take away on their journeys as well as containing information on the project and directions for contributing to the book racks.

Emma Rushton and Derek Tyman work collaboratively based in Manchester. They have recently completed a residency in Hong Kong as well as completing various socially oriented projects in the UK and Europe.

Asia Alfasi
The Non-savvy Non-commuter

Piccadilly Circus
December 2006 – April 2007

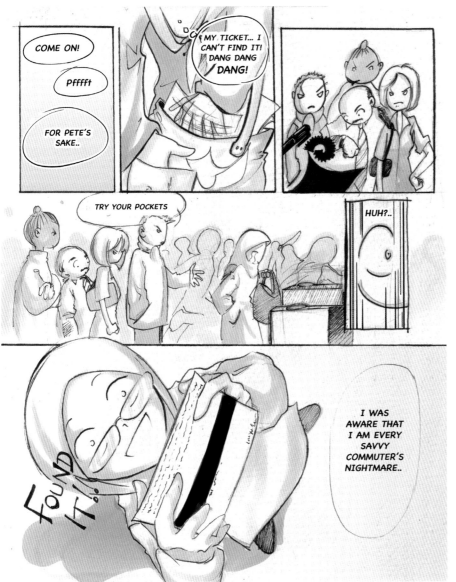

Alfasi's work is at times intimately autobiographical, focusing on her life as a young Muslim woman growing up in Glasgow and Birmingham. Taking the form of Manga style comic strips her works make use of her own experiences to analyse contemporary religious and political issues in an engaging and approachable manner.

For her commission for *Thin Cities* Alfasi produced a large-scale comic strip which was installed at Piccadilly Circus for five months. The comic detailed her experiences on the Underground and described her understanding of people's behaviour towards her on the Tube as she spoke in Arabic on her mobile and wore the Hijab. The work was a rumination on the deeply complicated social environment of the Tube and the broad cross section of cultures that use it on a daily basis.

Alfasi was born in Libya in 1985 before she moved with her family to Glasgow and Birmingham. She has recently completed a BA in Graphic Arts at the University of Central England in Birmingham and is in the midst of producing her first major graphic novel.

Asia Alafsi,
*The Non-savvy,
Non-commuter*, 2007.
Individual panel from a
series of 22 installed at
Piccadilly Circus.
Image courtesy of the artist.

Various Artists led by Nils Norman
Station of the Future Competition

Approximately 4,000 posters around the network
December 2006 – March 2007

A vital element of the *Thin Cities* project was the *Station of the Future Competition*. This was an open submission competition to which staff and members of the public were invited to submit artwork to. They were asked to design a station of the future that might serve generations to come. Platform for Art received over 300 entries from which three winners were choseon, one from each category – Staff, Children and Adults. The winning entries were produced as posters and exhibited extensively across the London Underground in unused advertising sites. Large-scale prints of the winning entries were also displayed in the new ticket hall of King's Cross St Pancras.

The winners were – Georgina Mackie (Staff), Jessica Katanga (Children) and Emma Louise Coates (Adults).

Station of the Future Competition poster.
Left – *Crystalline*, 2006, by Georgina MacIntyre, Staff winner.
Right – *Platform 3000*, 2006, by Emma Louise Coates, Adult winner.
Images courtesy of the artists.

POSTERS, PRINT WORKS AND OTHER PROJECTS

Bob and Roberta Smith
Shop Local

Posters across the network
August 2006

This project was developed in collaboration with Peer Gallery to coincide with the artist's exhibition there and in other sites in the Shoreditch area. The poster was produced to be inserted into advertising sites across the London Underground network, extending the reach of the exhibition from Shoreditch to the entire city.

The works were inspired by the faded advertisements from the early twentieth century that were painted on walls at a number of locations around Shoreditch. Bob and Roberta Smith's project tackles the issues raised by the blandness of today's average high street, and draws attention to how current economies of scale are squeezing the life blood from many independent and individual high street businesses.

Patrick Brill, better known by his pseudonym Bob and Roberta Smith (born 1963) lives and works in London. He completed a BA at the University of Reading followed by an MA at Goldsmiths. He has exhibited widely in the UK and internationally.

Bob and Roberta Smith,
Shop Local, 2006.
Poster design.
Image courtesy the artist
and London Underground.

RON'S EEL and SHELL FISH

welks, Smoked haddock, Rollmops sea food pieces, kippers, salmon etc...

every Friday and saturday Hoxton st. Market. SHOP LOCAL

Bob and Roberta Smith, Ron's Eel and Shellfish, 2006
A Platform for Art project to coincide with SHOP LOCAL, a project by Bob and Roberta Smith commissioned by Peer as part of The Shoreditch Festival (www. peeruk.org)
Platform for Art is the art programme for London Underground
Find out more and feedback at tfl.gov.uk/pfa

platform art

MAYOR OF LONDON

ARTS COUNCIL ENGLAND

PEER

SHOREDITCH FESTIVAL JOURNEYS

Transport for London

UNDERGROUND

Bill Fontana
Harmonic Bridge

Southwark station
July — August 2006

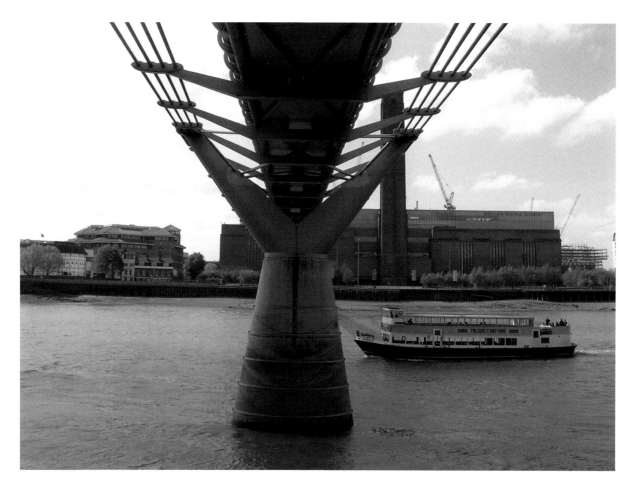

Bill Fontana,
Millenium Bridge,2006.
Image courtesy the artist.

Harmonic Bridge revealed the musicality of sounds hidden within the structure of the London Millennium footbridge, which is alive with vibrations generated by the collective energy of pedestrians and weather conditions. This usually inaudible sonic environment was transformed into a simultaneous sound installation in the intermediate concourse at Southwark Underground station and Tate Modern's Turbine Hall.

A network of recording devices called accelerometers was placed on different parts of the bridge in order to record its hidden musical life, transforming it into an enormous stringed instrument. These devices translate the vibrations and movements of the structure into sound. The sounds are then transformed into an acoustic sculpture by playing them back through a specially designed installation of loudspeakers.

Bill Fontana was born in Cleveland, Ohio, and lives and works in San Francisco and is known internationally for his pioneering experiments in sound art. He is interested in using the urban environment as a living source of musical information, and in the potential for its evocative qualities to conjure up visual imagery in the mind of the listener. Since the 1970s he has developed a practice based on real-time recordings of both natural and man-made events presented as site-specific sound installations.

The Ship: The Art of Climate Change

Poster Commission to coincide with the exhibition at the Natural History Museum
June – September 2006

This project was a collaboration between Platform for Art and the Natural History Museum to produce a poster to be presented in advertising spaces on the Tube to coincide with the exhibition The Ship: the Art of Climate Change at the Natural History Museum in 2006.

The exhibition was about the project Cape Farewell, which brings artists, scientists and educators together to collectively address and raise awareness about global warming. Created by artist David Buckland, Cape Farewell has led three expeditions into the wild, beautiful and icy High Arctic, a place for artistic inspiration and scientific enquiry.

The poster showed an image of a work by Siobhan Davies, photographed by Gautier Deblonde.

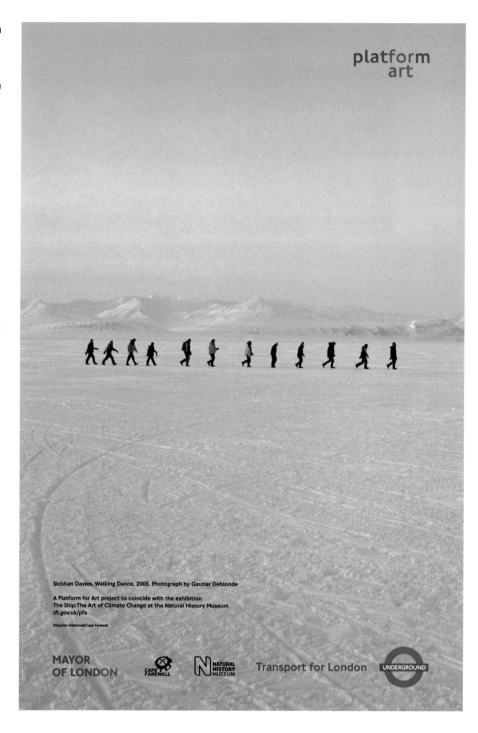

Gautier Deblonde
and Siobhan Davies,
Poster design, 2006.
Image courtesy the artists
and London Underground.

Royal College of Arts – Printmaking MA Graduates

South Kensington and Charing Cross
May 2006

Adam Bridgland,
Image for RCA posters
at South Kensington.
Image courtesy the artist.

This exhibition showcased the works of graduates from the 2006 Printmaking MA at the Royal College of Art. The students produced a series of images to be shown in the foot tunnel that runs between South Kensington Underground station and over 20 major cultural and educational institutions, including world-class museums, galleries and the Royal College of Art. The images were also exhibited as posters at Earl's Court and Charing Cross Underground stations.

Artists: Zoe Anderson, Elizabeth Eamer, Jonathan Ashworth, Isabel Albiol Estrada, Paul Bawden, David Evans, Phil Beeken, Phil Garrett, Ioannis Belimpasakis, Fiona Hepburn, Sarah Bridgland, Andrea Jesperson, Adam Bridgland, Tom Leighton, Giulietta Coates, Sarah Poynter, Hen Coleman, Akiko Takizawa, Roz Cran, Robin Tarbet, James Unsworth.

Ugo Rondinone

Posters across the network
February 2006

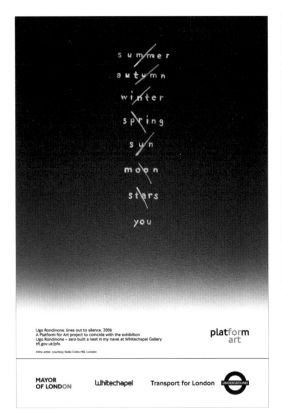

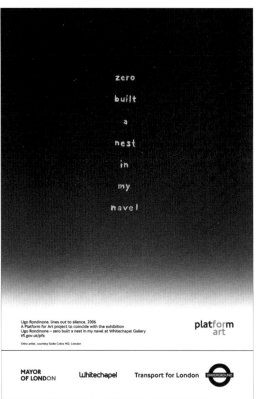

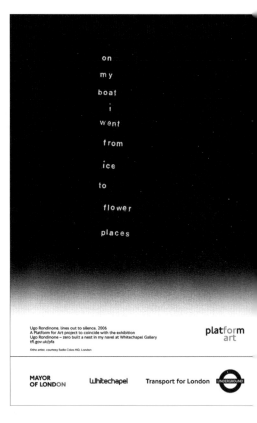

The project was a collaboration with the Whitechapel Art Gallery to coincide with the artist's exhibition zero built a nest in my navel, his first solo exhibition in a UK public gallery. It consisted of three posters designed by the artist to appear across the network.

The posters were developed from a series of images created from haikus the artist has been writing daily and transferring onto canvas. These meditative word-pictures draw the viewer into speculating on their meaning, reflecting one of the major themes of Rondinone's work – the search for authentic experience.

Described as a visionary trapped by reality, Ugo Rondinone takes us on a journey through the doors of perception. His works reflect on the conflict between reality and a world of mirrors, dreams and artifice.

Rondinone first came to international attention in the early 1990s with installations combining photography, video, painting, drawing, sculpture and sound. His exhibitions can include India ink landscapes in the Romantic tradition, or mesmerising target paintings that recall images of 1960s psychædelia. He combines works with an up-beat, pop sensibility with others that reflect a mood of longing and disconnection.

Ugo Rondinone was born in 1964 in Brunnen. He lives and works in New York and has exhibited widely in Europe and the United States.

Ugo Rondinone,
Untitled, 2006.
Poster designs.
Image courtesy the artist,
Whitechapel Gallery and
London Underground.

Braco Dimitrijević
A Casual Passer-By

Posters across the network
July 2005

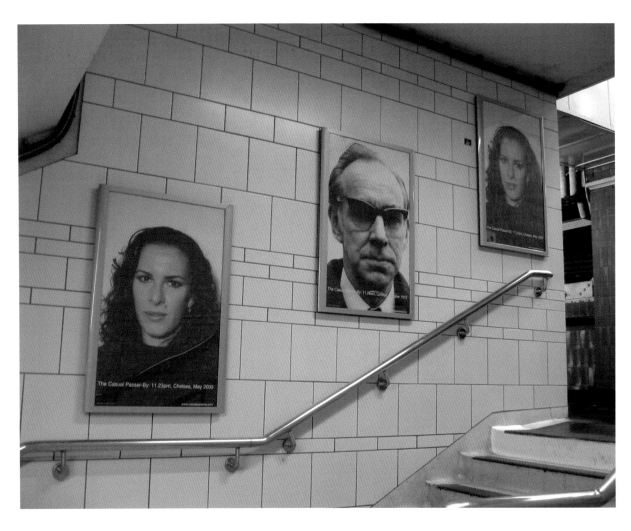

Braco Dimitrijević ,
A Casual Passer-By, 2005.
Installation view of posters
on the Underground.
Image courtesy the artist
and London Underground.

This project was the result of a collaboration with Tate Modern, Sadler's Wells and Viacom to produce posters that appeared across the Underground as well as on London buses across the city. It was a development of a project that the artist began in the 1970s when he photographed a passer by in the street and exhibited the image in sites around the city. The project coincided with Tate Modern's exhibition Open Systems: Rethinking Art in 2005.

Braco Dimitrijević met a woman at 9.30 on 24 June, 2005 on a street in London, took her photograph and asked her to sign a certificate to document the event. This chance encounter is the latest in a series of works, spanning 30 years, in which an arresting photograph of an unknown person is exhibited in a prominent city space. Works from this series, entitled *A Casual Passer-By*, have been exhibited in major cities worldwide, including Paris, New York, Zagreb, Venice, London and Berlin since 1971.

Braco Dimitrijević was born in Sarajevo in 1948. He studied at the Zagreb Academy of Art and Saint Martins School of Art, London. He currently lives and works in Paris.

Richard Wentworth
If London Looked in the Mirror

September – October 2005

> When is a Londoner not a Londoner? When does a long-term visitor become a Londoner? What makes people into Londoners? What must you know to be a Londoner? How long does it last?
>
> Richard Wentworth, June 2005

This commission was an artist's multiple in the form of a fold out poster available free from the Frieze Art Fair and all Zone 1 Tube stations in September and October 2005.

Wentworth has long been fascinated by the growth and development of London, and the various ways its inhabitants navigate and negotiate its urban geography. *If London Looked in the Mirror* prompts a consideration of how London has evolved and proposes a scheme for reacquainting Londoners with their city. The naming (and renaming) of London's parts has a contradictory history. Through a rearrangement of place-names on a rethought map of the city and a proposal for twinning its many boroughs, destinations, villages and landmarks, Wentworth's proposal aims to ensure that London's inhabitants become thoroughly familiarised with previously unknown places.

This project was the third of three commissions produced in collaboration with Frieze Projects to coincide with the annual Frieze Art Fair in October.

Richard Wentworth was born in 1947 in Samoa. He attended Hornsey College of Art from 1965 and was an assistant to Henry Moore in 1967. He has enjoyed an enormously influential career as an artist and is now Master of The Ruskin School of Drawing and Fine Art in Oxford.

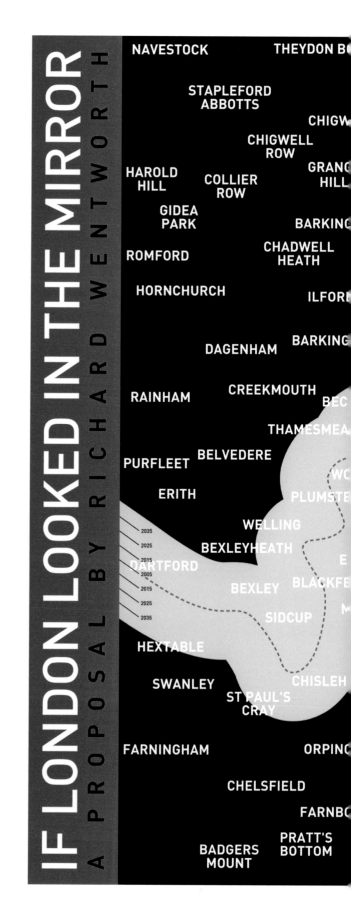

Richard Wentworth,
If London Looked in the Mirror, 2005.
A proposal by
Richard Wentworth.
Realised by Kit Grover.
Image courtesy the artists.

ON

HADLEY WOOD

BOREHAMWOOD

ENFIELD
COCKFOSTERS
BARNET
WATFORD
BUSHEY

PONDERS
END
WINCHMORE
HILL
ELSTREE
OXHEY

CHINGFORD
TOTTERIDGE
BUSHEY
HEATH
RICKMANSWORTH

SOUTHGATE
WHETSTONE

HURST
LL
EDMONTON
SOUTH
OXHEY

FRIERN
BARNET
STANMORE
NORTHWOOD

WOODFORD
TOTTENHAM
WOOD
GREEN
MILL HILL
EDGWARE
HATCH
END
FINCHLEY

WALTHAMSTOW
MUSWELL
HILL
HENDON
KENTON
HARROW
PINNER
DENHAM

HORNSEY
KINGSBURY

ANSTEAD
HIGHGATE
GOLDERS
GREEN
HARROW
ON THE HILL
RUISLIP

LEYTON
STOKE
NEWINGTON
HAMPSTEAD
CRICKLEWOOD
ICKENHAM

ANOR
ARK

HACKNEY
ISLINGTON
CAMDEN
TOWN
WILLESDEN
NORTHOLT
UXBRIDGE

WEST
HAM
BETHNAL
GREEN
CLERKENWELL
KILBURN
WEMBLEY
HILLINGDON

STEPNEY
REGENT'S
PARK
PARK
ROYAL
GREENFORD

POPLAR
CITY
HOLBORN
PADDINGTON
EALING
HAYES

BERMONDSEY
WESTMINSTER
SHEPHERD'S
BUSH
ACTON
SOUTHALL
WEST
DRAYTON

LAMBETH
KENSINGTON

DEPTFORD
CHELSEA
HAMMERSMITH
BRENTFORD
HESTON

GREENWICH
BARNES

OKE
CAMBERWELL
BATTERSEA
FULHAM
ISLEWORTH

BRIXTON

LEWISHAM
CLAPHAM
PUTNEY
RICHMOND
HOUNSLOW
HEATHROW

HERNE
HILL
WANDSWORTH

CATFORD
RICHMOND
PARK
TWICKENHAM
WHITTON
PROPOSED
THAMES
RIVER
WIDENING
PROGRAMME
2005/40

HAM
DULWICH
ASHFORD

STREATHAM
WIMBLEDON
FELTHAM

DOWNHAM
CRYSTAL
PALACE
NORBURY
TEDDINGTON

PENGE
KINGSTON
UPON
THAMES
EAST
MOLESEY
SUNBURY

BECKENHAM
MERTON
NEW
MALDEN

MITCHAM

BROMLEY
MORDEN
SHEPPERTON

AYES
THORNTON
HEATH
SURBITON
WALTON-
ON-
THAMES
CHERTSEY

ROSE HILL

WEST
WICKHAM
SHIRLEY
BEDDINGTON
TOLWORTH
LONG
DITTON
WEYBRIDGE

KESTON
CROYDON
CARSHALTON
SUTTON
ESHER

NEW
ADDINGTON
CHEAM
CHESSINGTON
CLAYGATE
HERSHAM

PURLEY
EWELL
EPSOM

E
SANDERSTEAD
MALDEN
RUSHETT
FAIRMILE

WARLINGHAM
BYFLEET

Mark Dion

Posters across the network
September – December 2005

Mark Dion,
Poster design, 2005.
Image courtesy the artist,
South London Gallery and
London Underground.

Two new poster works produced by artist Mark Dion working in collaboration with Robert Williams appeared in advertising sites across the network. The project was a collaboration with South London Gallery to coincide with its exhibition *Microcosmographia*, Dion's first major solo exhibition in a UK public gallery.

The posters showed images of drawings based on eighteenth century biblical illustrations of cyclogenic trees that have been changed into fictional family trees, one of alchemists and one of naturalists. The apparently arbitrary and fantastic selection of names, ranging from Hermes Trismegisthus to Marcel Duchamp on one, and Aristotle to Attenborough on the other, are given a strange credibility by their appropriated antique context.

Mark Dion was born in New Bedford, Massachusetts in 1961. He now lives and works in Beach Lake Pasadena. Over the past 20 years, he has produced a wealth of internationally acclaimed projects, often created collaboratively, that explore our perception, classification and consumption of knowledge.

Lucy Skaer
Tatlin's Tower & the World

Posters across the network
March 2005

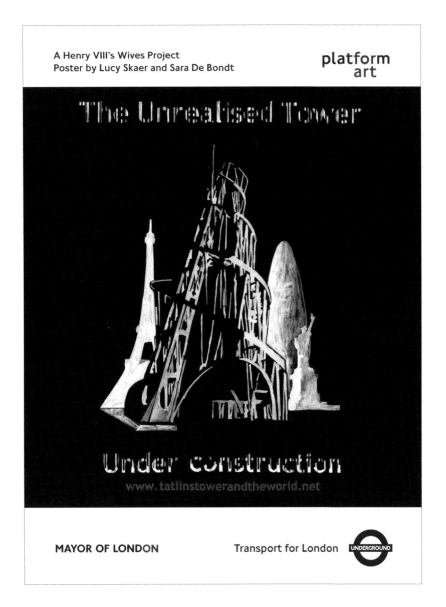

A Henry VIII's Wives Project
Poster by Lucy Skaer and Sara De Bondt

platform
art

The Unrealised Tower

Under construction
www.tatlinstowerandtheworld.net

MAYOR OF LONDON Transport for London UNDERGROUND

Lucy Skaer,
*Tatlin's Tower &
the World*, 2005.
Poster design by Lucy
Skaer and Sara De Bondt.
Image courtesy the artists.

The project existed as part of a larger work by the artists' collective, Henry VIII's Wives, of which Lucy Skaer is a member. Henry VIII's Wives aimed to build the unrealised Utopian Tower designed by artist Vladimir Tatlin in the 1920s. The posters were artworks that also functioned to alert people to the Tatlin's Tower project, communicating it as a conceptual idea to users of the London Underground. The posters operated as an artistic investigation of the realm of advertising and propaganda: each is both a political and economic tool. Publicity generated by the posters contributed towards the realisation of the wider project.

Lucy Skaer lives and works in Glasgow. She is an artist who, early in her career, has already exhibited widely in the UK and internationally. She was shortlisted for Beck's Futures 2003.

Gabriel Orozco

Posters across the network
June – September 2004

Orozco's poster project featured a photograph of kites in a tree, a situation that the artist encountered while travelling in India. It appeared at random advertising sites on the Underground, echoing the element of chance in Orozco's work. The poster was produced and presented in collaboration with the Serpentine Gallery to coincide with the exhibition of Orozco's work.

Orozco's photographs, sculptures, and installations propose a distinctive model for the ways in which artists can affect the world with their work. His work has been exhibited at distinguished venues including the Whitney Museum of American Art, the Museum of Modern Art, the Solomon R. Guggenheim Museum, the Philadelphia Museum of Art, and the Venice Biennale. Gabriel Orozco lives and works in New York, Paris, and Mexico City.

Gabriel Orozco was born in 1962 in Jalapa, Veracruz, Mexico and was educated in the Escuela Nacional de Artes Plasticas. He then continued his education in Madrid at the Circulo de Bellas Artes.

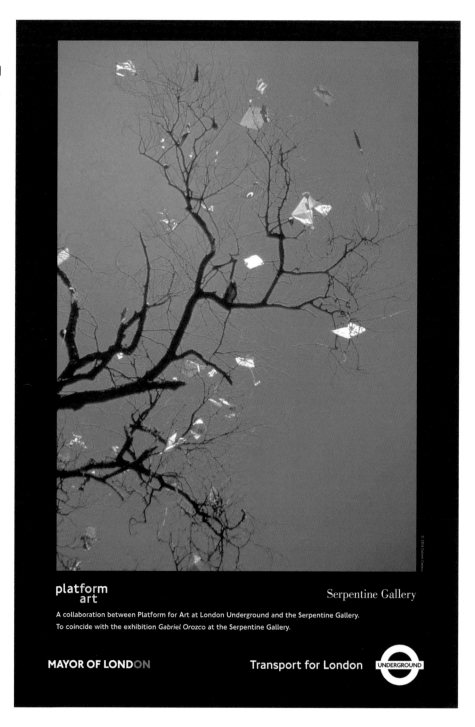

Gabrielle Orozco,
Poster design, 2004.
Image courtesy the artist,
Serpentine Gallery and
London Underground.

Liam Gillick
headache/phone card/soda/donuts/stereo

Great Portland Street
September 2003 – January 2004

Liam Gillick,
*headache/phone card/soda/
donuts/stereo*, 2003.
Installation detail at Great
Portland Street station
Image courtesy the artist
and London Underground.
Photo: Stephen White.

Gillick created a set of specially produced posters to go into unused advertising sites all over Great Portland Street Underground station. The posters all featured simple typography, strong pattern and single colours. The works made use of transcripts of non-specific television advertising – placing the structure of one communication medium into another. The structure of the message overwhelms the product and we are left to reflect on the potential of narrative and presentation.

This project was the first of three commissions produced in collaboration with Frieze Projects to coincide with the annual Frieze Art Fair.

Liam Gillick was born in 1964 in Aylesbury, Buckinghamshire. He studied at Goldsmiths College, University of London from 1984–1987. He lives and works in London and New York. In 2002 Gillick was a Turner Prize finalist and had a major solo exhibition, The Wood Way, at the Whitechapel Art Gallery. He has since, amongst many other projects, been commissioned to make a permanent work at The Home Office, London.

Platform for Art Online

Launched November 2003

Platform for Art Online was produced in 2003 to be a digital arm for Platform for Art to expand the reach of the London Underground art programme, presenting the work of UK and internationally based artists to a world-wide audience.

Platform for Art Online, conceived and developed to show work made by artists using new media and computer technologies, presents selected pieces from the range of vibrant and exciting work being developed in this field. 15 works, by UK and internationally based artists, were on the site for its launch.

The works are presented within an interface, designed and developed by website designers, Airside, to exploit the latest in Internet technology.

Visitors find themselves in an animated caricature version of the London Underground network. They can select 'journeys' and travel on 'trains' to a series of platforms, each of which represents a different work. They will meet bizarre and amusing characters who will offer helpful (and sometimes not so helpful!) tips about the site or the artist they are looking for.

Participating artists:Soo Yeun Ahn, Marketa Bankova, Nina Pope and Karen Guthrie, Andreas Hofer, Ilana Halperin, Janette Parris, Joerg Piringer, Melinda Rackham, Teamchman, Florin Tudor, Alun Ward, Roxanne Wolancyzk, Neil Zakiewcz.

Platform for Art Online,
Screen grab.
Design by Airside.
Courtesy the designers
and London Underground.

Go to the Gallery

April 2003

A range of London-based galleries contributed art works to be selected for reproduction as posters to be distributed in sites across the network, including redundant retail units, advertising, blank walls and hoardings. The project extended the reach of the Platform for Art programme into a greater range of sites; providing an interface to reflect London's vigorous art scene and bringing the work of emerging as well as leading established artists into the London Underground network.

Participating galleries and artists: Art for Offices: Annie Lovejoy, Bookworks: Mark Hosking, www.bowieart.com: Nina Sverdvik and Peter Lloyd, Camden Arts Centre: muf architecture/art, Crafts Council: Clare Twomey, Danielle Arnaud contemporary art: Glauce Cerveira and Gerry Smith, Entwistle Gallery: Rosa Loy and Dan Holdsworth, Frith Street Gallery: Fiona Tan, Stephen Friedman Gallery: David Shrigley, Yoshitomo Nara and Kendell Geers, Hales Gallery: Ben Ravenscroft, Laurent Delaye Gallery: Rut Blees Luxemberg and Mark Dean, Lisson Gallery: Jane & Louise Wilson, Tony Oursler, Matt's Gallery: Matthew Tickle, Jo Bruton, Andrew Mummery Gallery: Chila Kumari Burman, MWprojects: Christian Ward and Nigel Shafra, One in the Other: Simon Linke, Photographers Gallery: Jitka Hanzlová: Pump House Gallery: Axel Antas and Abigail Hunt, Rhodes + Mann: Kate Davis, Emily Tsingou Gallery: Georgina Starr, Sophy Rickett, Union Projects: Scott McFarland, Vilma Gold: Mark Titchner, White Cube: Sarah Morris and Marc Quinn.

Go to the Gallery,
Poster design.
Image: Fiona Tan, *Lift*, 2003.
Courtesy the artist
and Frith Street Gallery.

COMMUNITY PROJECTS

Gayle Chong Kwan
Journey to the Centre of the Earth

Southwark and London Bridge stations
July 2007

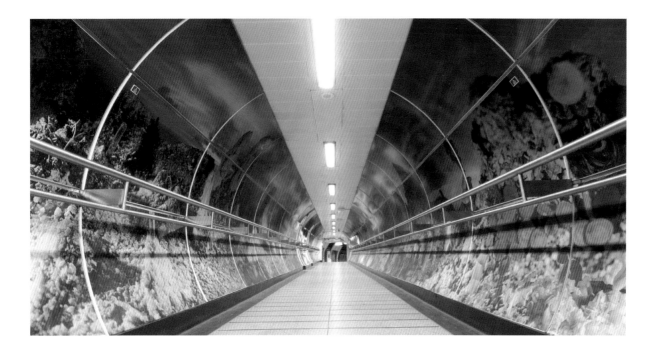

Gayle Chong Kwan spent six months working with station staff, Southwark College catering students, market traders and staff at the restaurant 'Roast' to create a series of fantastical Underground sensory worlds around London Bridge and Southwark stations.

The project brings together people from London's distinct and varied cultures to explore the culinary history of the Underground, ideas of imaginary subterranean travel and the culinary heritage of the participants.

The title of exhibition comes from Jules Verne's eponymous novel that illustrated a voyage through strange underground worlds towards the earth's core. It featured caverns of giant mushrooms, underground seas and referred to bodily digestion and the cooking of the earth. Verne's novel was written at a time when voyages of discovery of 'new worlds' were in vogue and anticipated the major drive for colonialism.

Journey to the Centre of the Earth follows on directly from the artist's billboard installation outside Southwark station, a series of Utopian landscapes inspired by the fourteenth century fictional glutton's paradise, Cockaigne, a land entirely made of food.

Journey to the Centre of the Earth comprises three large-scale art works:
Hollow Earth – a billboard work wrapped around Southwark Tube station using images of food that grow underground and based on seventeenth century 'hollow earth' theories.
Core – a red volcanic landscape made from food blended against night skies that references the journey into the actual core at the centre of the earth. The work entirely enveloped a foot tunnel at London Bridge station.
Intra – a window display at the entrance of London Bridge station which provides a gateway to Borough Market. It connects the experience of eating as a journey into the packaging and foodstuffs from the celebrated market.

Gayle Chong Kwan with Borough Market traders, London Underground staff, Roast restaurant workers, and Southwark College students, *Hollow Earth*, 2007. Photo: Daisy Hutchison.

Gayle Chong Kwan
Cockaigne

Southwark station
November 2006 – April 2007

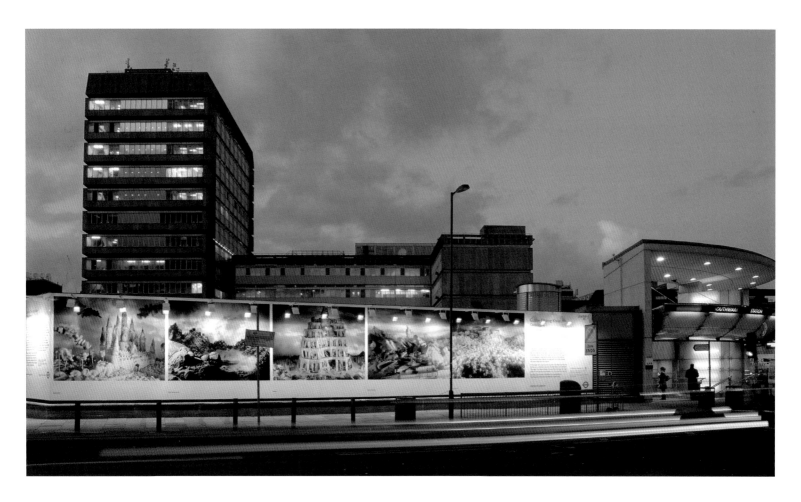

Gayle Chong Kwan,
Cockaigne, 2006/2007.
Installation at
Southwark station.
Photo: Daisy Hutchison.

Inspired by Utopian legends and developments in global tourism, Gayle Chong Kwan's images depict a range of fantastic landscapes set against dramatic skies. The fourteenth century myth of the Land of Cockaigne, a paradise where work is forbidden and every human desire is catered for, is the major influence behind this work.

In these images, Chong Kwan has, quite literally, produced a feast for the eyes where instead of brick, stone and concrete there are villages of oats, bread castles and mountains of chocolate.

Cockaigne is a commission by Autograph and marked the start of a six month residency by the artist in collaboration with local people.

Gayle Chong Kwan's practice features elements of photography, video, installation and performance. Often sited outside of conventional gallery spaces, it enables the audience to physically engage with the work, or can be the result of a process of working with notional communities. Her work plays with notions of communication, participation and authorship through Utopian ideas, food, culinary rituals, tourism, trade, memory and the senses.

Chong Kwan, born 1973, Edinburgh is a Scottish-Chinese Mauritian artist.

Tajender Sagoo
My Flag

Kingsbury station
May 2007

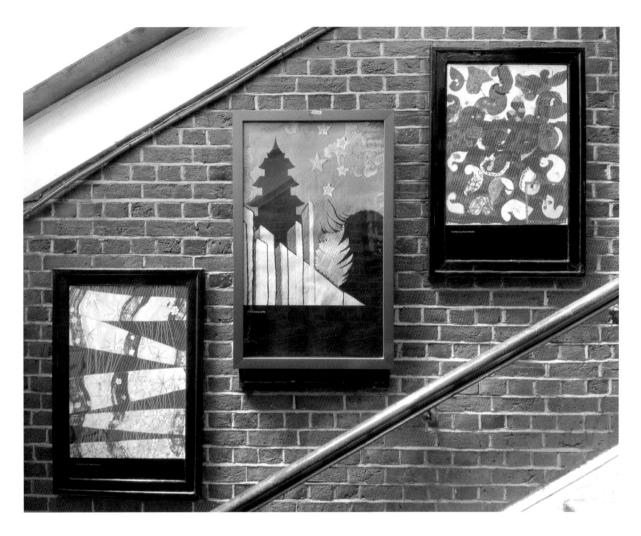

An exhibition of posters by students from Kingsbury High School in collaboration with Tajender Sagoo. *My Flag* is a series of flags made by school students symbolising cultures, languages, traditions and religions from across the world. The students have drawn ideas from their family backgrounds and from research into different cultures. Islamic architecture, Buddhist symbols, shapes and jewellery traditionally worn by South Indian dancers, oranges commonly used in Indonesian fabrics and the hot colours of African landscapes are examples of the different visual references that can be seen in the flags. Tajender Sagoo worked with the students to explore new techniques in sewing, printing and painting to weave their ideas together and create these lustrous and vibrant personal emblems.

Tajender Sagoo is an artist based in Limehouse, who uses textiles, specifically weaving and photography in her work. She explores themes in post-colonial history, both personal and historical, while referencing contemporary culture and its notions of revisionism and the primitive. Tajender Sagoo has exhibited across the UK and also outside the gallery context. She lives and works in London.

Tajender Sagoo in collaboration with students from Kingsbury High School, *My Flag*, 2006. Photo: Daisy Hutchison.

Carl Stevenson and Anna Boggon
The Waiting Room

Dagenham Heathway and Upney stations
June 2007

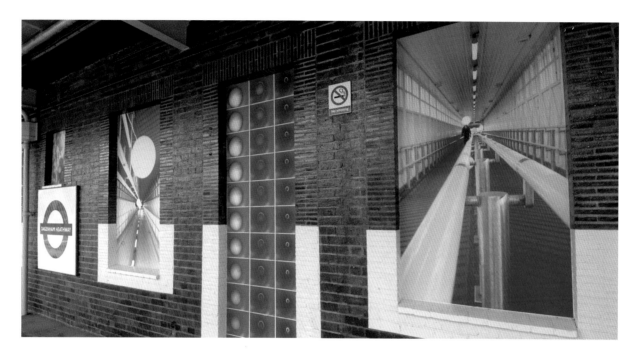

Anna Boggon and Carl
Stevenson collaboration,
The Waiting Room, June 2007.
Dagenham Heathway station.
Photo: Daisy Hutchison.

A contemporary art scheme aimed at discouraging graffiti and vandalism by encouraging the minority of young people who behave anti-socially to take pride in the Tube.

The Waiting Room was commissioned by Platform for Art and Transport for London's Crime & Disorder Partnership Unit. The exhibitions were on display for six months at Dagenham Heathway station and Upney station. Students aged 14–18 from Barking Abbey and Dagenham Park Community schools worked in collaboration with contemporary artists Anna Boggon and Carl Stevenson to devise artistic experiments that responded to waiting rooms and other hidden spaces in the stations. They used techniques of mapping, boundaries, movement and memory to create images and words to be exhibited in waiting rooms, platforms and walkways, and on building site hoardings whilst Upney station was refurbished.

This was the first time that Platform for Art and the Crime & Disorder Partnership Unit worked together

to create a positive scheme where station staff and young people who may consider anti-social behaviour build relationships and work together.

Anna Boggon's practice includes sculpture, video and site-specific installation. Each artwork is investigative in its approach, often playful, and at times humorous. The process involves a weaving of research and an ongoing curiosity relating and to the adaptability of objects and subject matter, there is often an interplay between fact and fiction.

Anna has exhibited internationally and was awarded the British Council Artists Link Residency in China 2005–2006. She lives and works in London.

Carl Stevenson is a filmmaker. He explores social, personal and the emotional space, using pseudo scientific and forensic methodologies to reveal invisible connections and possibilities. He lives and works in London.

Wimbledon College of Art and Morden Women's Institute Knitting Circle

South Wimbledon station
April – October 2007

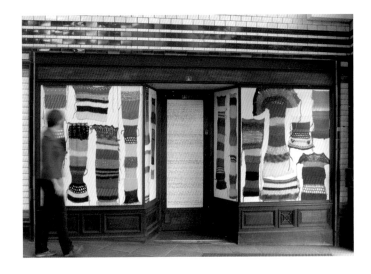

An exhibition by ten students of Wimbledon College of Art produced in collaboration with the Morden Women's Institute

Ten students at the College run a weekly Knitting Club. The exhibition narrates a series of encounters between the artists' Club and members of the local Women's Institute. Exploring the resurgent craft of knitting as a social activity the meetings opened up a context for engagement and exchange. The joint workshops were occasions for chatting, sharing advice, techniques and patterns. The resulting knitted lengths are a detailed physical chart of the time the groups spent together and were exhibited in shop windows at South Wimbledon station. This project was developed in a partnership with the Engine Room at Wimbledon College of Art .

Artists – Janet Burchell, Sarah Colman, Isobel Dunhill, Sophie Goldthorpe, Aileen Harvey, Barney Heywood, Grace McMurray, Shyama Persaud, Martina Volfikova, Tomoko Yamaguchi.

John Simmons with staff from King's Cross station King's Cross is Rising

King's Cross station
April 2007

John Simmons was writer in Residence at King's Cross to work with LU staff at King's Cross. This project focussed on writing and storytelling, to produce a project template to be applied to other stations with other writers.

Simmons worked in collaboration with staff to create stories and prose that capture working life at King's Cross – its highs and lows, big events and everyday details, sometimes dramatic, sometimes funny. These stories were brought together in a booklet distributed to staff on the Hammersmith and Circle line.

Left: Knitting Circle,
Various artists in collaboration with Morden Women's Institute,
South Wimbledon station, 2007.
Photo: Daisy Hutchison.

Right: John Simmons in collaboration with King's Cross staff, *King's Cross is Rising*, 2007.

Othello De'Souza Hartley & Courttia Newland
Connected

Westminster station
December 2006 – April 2007

Othello De'Souza Hartley,
Cricket Driver, 2006.
Image courtesy the artist.

Connected was part of the Generations project, celebrating the 50th anniversary of London Transport's Direct Recruitment scheme in the Caribbean. As a result of labour shortages following World War II, London Transport began to recruit directly from the West Indies, inviting men and women to become bus conductors, Underground staff, and canteen assistants. The shortage of labour created opportunities for thousands of people to emigrate to Britain and work for London's public transport network. Platform for Art invited four individuals to share their stories with photographer Othello De'Souza Hartley and writer Courttia Newland. Newland documented these memories, providing a fleeting glimpse into their personal and working lives. Live readings of Newland's stories by actors were also held at Westminster Underground station for passing Tube customers.

Othello De'Souza Hartley has worked commercially as a fashion and portrait photographer. Recent commissions include a residency at The National Trust's Sutton House to produce a film and photographic installation exploring Caribbean heritage. He also had a solo exhibition at Camden Arts Centre in 2005. He is currently working on a portrait commission for The National Portrait Gallery. Courttia Newland is the auther of three critically acclaimed novels, The Scholar, 1998, Society Within, 1999 and Snakeskin, 2002. His short stories have been published in many anthologies and several of his plays have been performed in venues across London.

Various artists/Serpentine Gallery/
North East London Mental Health Trust
Hearing Voices, Seeing Things

Bromley by Bow, Hainault, Leytonstone, Mile End
September – October 2006

The Serpentine Gallery worked with staff and
service users of North East London Mental
Health Trust on a two year integrated programme
of artists' residencies and commissions. Led by
artists Bob and Roberta Smith, Jessica Voorsanger
and The Leytonstone Centre of Contemporary Art
(LCCA), with Mel Brimfield and Sally O'Reilly, Karen
Densham, Mandy Lee Jandrell, Andy Lawson and
Victor Mount, projects included photography,
ceramics, sound works, comedy events and the
design of a new font. An exhibition of the project
took place in a replica version of the LCCA at the
Serpentine Gallery.

Platform for Art commissioned three posters
by the artists which were displayed on London
Underground in the North East London area and a
postcard by Jessica Voorsanger entitled "What's
So Funny?" inviting people to send in their jokes,
was distributed across the network.

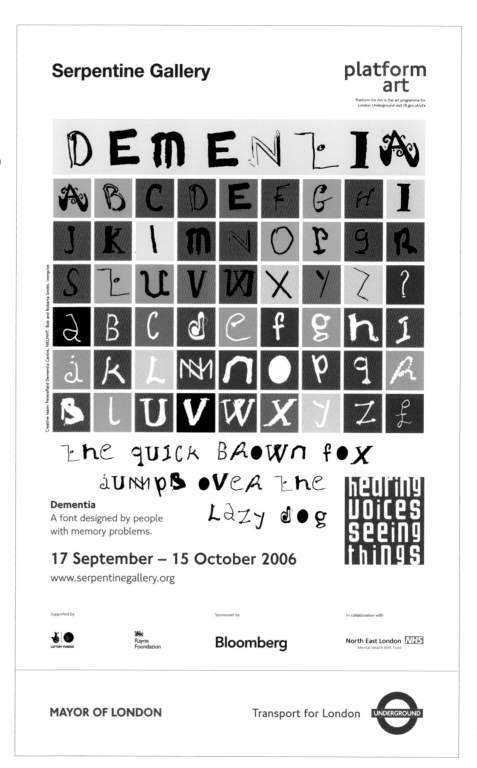

Dementia Font
Artists: Petersfield Dementia
Centre, NELMHT, Bob and
Roberta Smith, Immprint.

London College of Fashion Photography Students
Bakerloo Centenary

Artists – Gemma Stokes, Fabrice Lachant, Panagiotis Davios, Priten Patel,
Rama Lee, Louise Aldophsen, Sarah Brittain Edwards
Various sites
March 2006 – February 2007

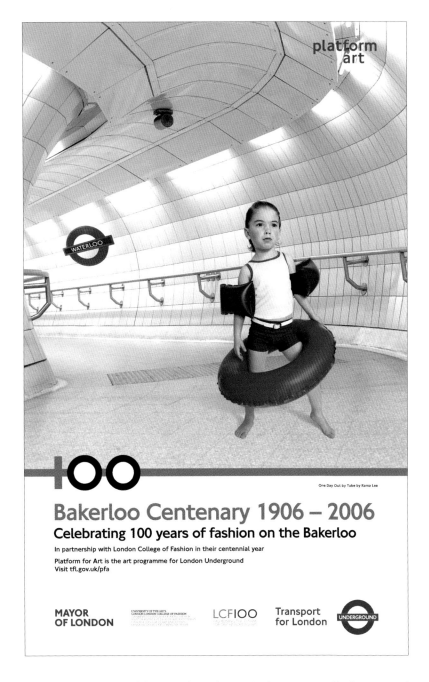

Rama Lee,
One Day Out by Tube, 2006.
Poster design.
Image courtesy the artist
and London Underground.

Ten posters inspired by ten decades of fashion and design on the Bakerloo line, 1906–2006, as part of the wider Bakerloo centenary celebrations. The posters were produced in collaboration with the London College of Fashion, also celebrating their centennial year.

Each poster thematically linked the history and design of the Underground, making reference to specific stations, and fashion trends through the century.

Suki Dhanda
Year of the Dog

Posters across the network
January – April 2006

To celebrate the Chinese Zodiac Year of the Dog 2006, Platform for Art and the Photographer's Gallery commissioned ten photographic portraits of dogs and their owners by photographer Suki Dhanda. The portraits were shown on posters in stations throughout London. Postcards were also distributed on ticket barriers at Leicester Square Underground station to coincide with the Chinese New Year festival.

Suki Dhanda spent a month exploring the diversity of London's dog ownership, and observing the way dogs interact with their owners at home and in public spaces. The project celebrates how the love of dogs transcends cultural barriers. Platform for Art also invited the public to submit photos of friends and family with their dogs for a special exhibition on the Platform for Art website.

Suki Dhanda lives in London. She studied photography at Plymouth College of Art and is a successful photographer and regular contributor to *The Observer* magazine. Dhanda was one of eight photographers commissioned by the British Council to focus on aspects of Contemporary Muslim Experience in Britain.

Suki Dhanda,
Asher, Cassie, Harlem and Blaze, 2006.
Image courtesy the artist.

Students from the Central Academy of Fine Arts, Beijing, Nanjing Normal University, Nanjing, and the University of Westminster, London
China Dreaming

Southwark
February – April 2006

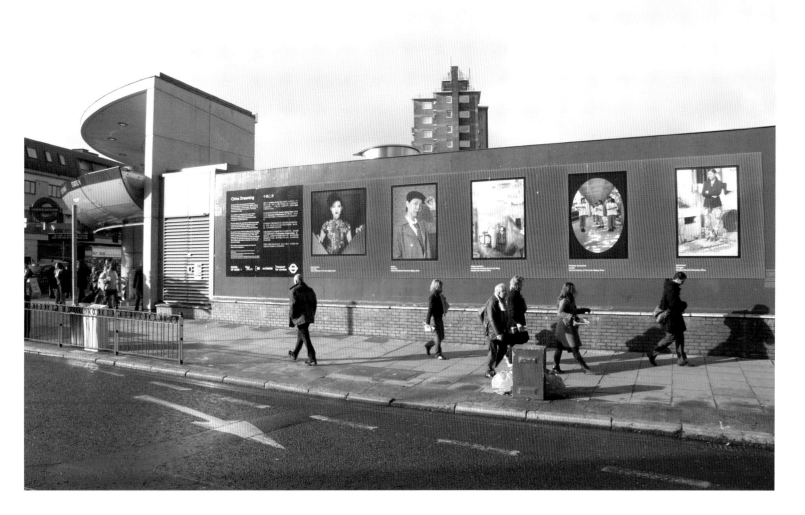

Various artists,
China Dreaming, February
2006. Southwark station.
Photo: Stephen White.

This exhibition, in partnership with London Gallery West and University of Westminster showcased new contemporary photography by young Chinese artists in celebration of Chinese New Year.

The work explores the extraordinary differences emerging in the lives of young people, the appearance of the city and the contrasts with ancient traditions, as China continues to be the world's fastest expanding economy.

The students work explores genres from documentary to fantasy and presents an exciting mix of journeys into the past and future. They have explored youth culture and identity and the impact of new technology.

Soho Parish Primary School
Chinese Treasures

Leicester Square and Westminster stations
January – April 2006

Chinese Treasures is a display of work by children of Soho Parish Primary School in a collaboration with the Education Department of the Royal Academy of Arts. 22 students, aged seven to eight years, created a collection of contemporary paintings and drawings inspired by treasures of the Qing Dynasty, following a visit to the RA exhibition China: The Three Emperors, 1662–1795.

The childrens' responses included a digital clock with wings, a hoover adorned in elaborate Chinese characters, a dragon shaped car and a flowering bicycle.

The works were reproduced for two exhibitions at Leicester Square and Westminster stations.

Soho Parish Primary School,
Chinese Treasures, 2006.
Design by James Merry.
Image courtesy the artists.

Ella Gibbs and Amy Plant
A Station Musical for Stratford

Stratford
March 2006

Ella Gibbs and Amy Plant,
*A Station Musical for
Stratford*, 2006.
Stratford station.
Photo: Daisy Hutchison.

Inspired by the nearby 2012 Games, the artists led a series of workshops with children from Carpenters Primary School – the closest school to the official site – as well as station staff and passengers. The result was a 50 metre frieze which was exhibited in the mezzanine window at Stratford Underground station, reflecting the local pride, diversity and culture of the Stratford area. Working with designers Åbäke, Plant and Gibb completed the piece by adding the names of all the participants using a customised version of the font Gill Sans Ultra Bold – a reference to Johnston, who created the London Underground typeface and under whom Gill was a student. The resulting frieze was a visual statement

for a 'musical' – a reference to Stratford's historical connection to the birth of the music hall – expressing what it means for Stratford's community to be a key part of the monumental events happening in 2012.

Artists Amy Plant and Ella Gibbs live and work in London and set up Pilot Publishing in 2004. Pilot Publishing led a community collaboration project, commissioned by The Drawing Room in 2004, to produce a street magazine made by people who live, work and pass through Laburnum Street.

Motiroti
Priceless

South Kensington station and foot tunnel
August 2006

Priceless was a Serpentine Gallery-led initiative in partnership with the Exhibition Road Cultural Group (ERCG). Asked to pick what they consider to be their priceless object by project co-ordinators, arts group motiroti, Platform for Art nominated South Kensington Tube station and its staff. The work produced was exhibited as part of a large-scale show within the organisations of the ERCG – which includes all the major institutions on Exhibition Road, including Goethe Institute London, Imperial College, Natural History Museum, Royal College of Art, Royal Geographical Society, Royal Parks, Serpentine Gallery, Science Museum and V&A. Working with South Kensington staff, motiroti investigated their personal and social interactions and recorded sound, video and writing, which they subsequently translated into a series of graphic portraits and maps installed in South Kensington foot tunnel.

motiroti is a group of artists (founded by Ali Zaidi and Keith Khan). It supports existing groups, small or large, to create customised art projects that excite imaginations, examine cultural values and precipitate change. It encourages and supports the work of new artists, and pushes the boundaries of new technology.

motiroti,
Priceless, 2006.
Design for South Kensington
foot tunnel.
Image courtesy the artists.

Poulomi Desai
Red Threads

North Harrow
May 2006 – April 2007

Indu Amin in collaboration with Poulomi Desi, *Red Threads*, 2006. Image for poster design at North Harrow station. Image courtesy the artists.

An exhibition of digital portraits created by Harrow residents inspired by the work of locally-based artist Poulomi Desai. The 41 images, which form an intriguing, playful and visually dynamic representation of Harrow's diverse neighbourhood, were produced by residents through a workshop led by the artist. Images were exhibited at North Harrow station in a year long celebration of the area. The artist and residents experimented with costume, disguise, and facial expression and body language, recorded through photography. These photographs were then further altered by patterns in pastel and paint.

Poloumi Desai has been exhibiting work for over 20 years across the UK and internationally.

Arsenal Football Club with Greenwich Mural Workshop
The Final Salute

Arsenal station
January 2006 – January 2007

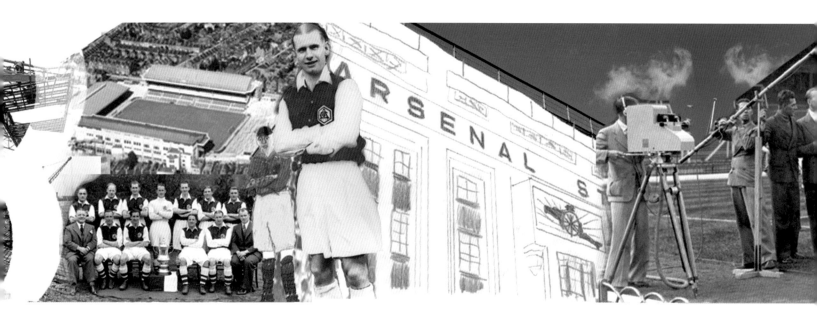

For 93 years Arsenal Stadium in Highbury was home to Arsenal Football Club, and 2006 saw their last season there before taking up residence in the new Emirates Stadium.

Platform for Art collaborated with Arsenal Football Club and Greenwich Mural Workshop to produce a mural – The Final Salute – which celebrated the passionate memories and proud local community involvement with and ownership of Arsenal's historic residence at Highbury. This mural was situated along the passageway to the ticket office at Arsenal station.

Although the finished work references both Arsenal's previous home in Woolwich and the new Emirates Stadium, the main focus of the mural was their history at Highbury. All three collaborators engaged and consulted with the local community, London Underground staff and Arsenal players and fans in the design of the mural. Photographic and other relevant material on the football club's history was gathered and selected from fans and Arsenal's own museum to contribute to the completed work.

A series of workshops produced vibrant and exciting imagery to add to the historic archive material and this was digitally arranged and fused into one long narrative composition that seamlessly traced the story of this historic and much-loved football club.

Greenwich Mural Workshop in collaboration with Arsenal fans, *The Final Salute*, 2006. Arsenal station. Image courtesy the artists.

Marysa Dowling with Wessex Girls' Group
Mine

Aldgate East station
November 2005

Marysa Dowling and Wessex
Girls' Youth Group,
Mine, 2005.
Installation at Aldgate
East station.
Image courtesy the artists
and London Underground.
Photo: Daisy Hutchison.

Wessex Girls' Youth Group worked with artist
Marysa Dowling to explore issues around race and
identity inspired by the Whitechapel exhibition
Back to Black – Art, Cinema and the Racial
Imaginary, 2005.

For *Mine* the group produced a series of digital
photographic compositions that were enlarged
to fit the alcoves in Aldgate East station. These

images expressed their feelings about identity
and highlighted issues concerning race and
representation. With their hands painted with
henna in the mehndi tradition, the young women
experimented with clothes and props including
masks, wigs and veils in order to produce self-
portraits that highlight their individual, personal
expressions through fashion and disguise.

Martin Barron
Motion

South Wimbledon station
July – December 2005

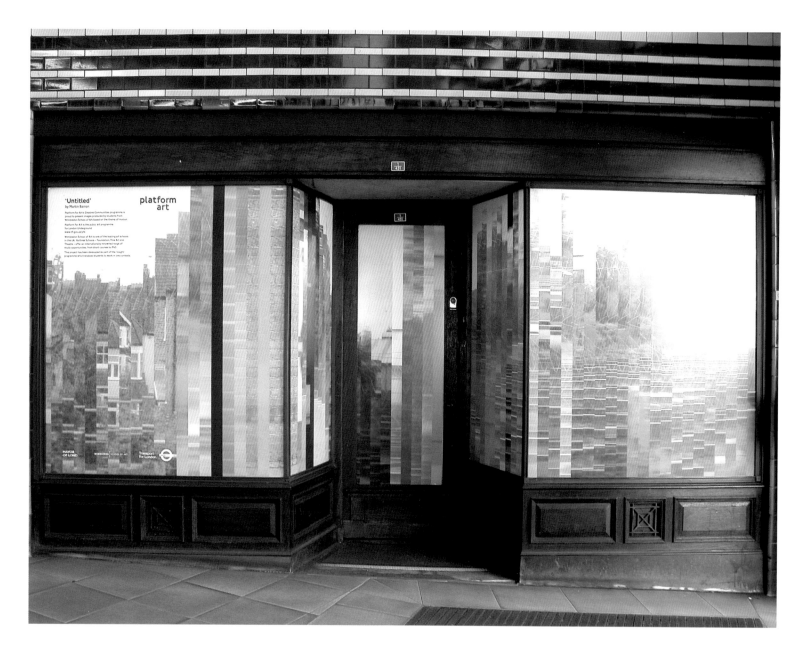

The second of three new works by Wimbledon College of Art students presented in empty window spaces in a retail unit at South Wimbledon station. The works respond to the theme of motion, and were the result of a partnership with the art school. The artwork was a large image that wrapped around the front and side of the station, designed to create maximum visual impact.

Martin Barron, *Motion*, 2005. Installation at South Wimbledon station. Image courtesy the artists and London Underground.

Matt Collier
Post Selection Translation

South Wimbledon
December 2005 – March 2006

Feltham Young
Offenders' Institute
Southwark Mural

Southwark station
2004

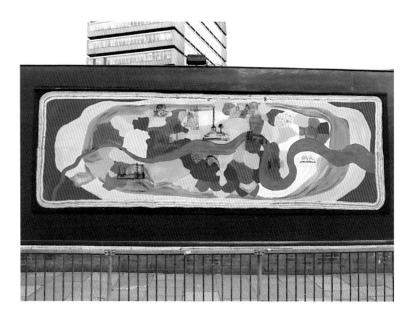

Post Selection Translation filled the windows of a retail unit at South Wimbledon station as part of an ongoing partnership with Wimbledon College of Art. It featured anatomic forms drawing parallels between the human body's internal scaffolding and the station's architecture.

Matt Collier was born in 1977 and graduated with a degree in Fine Art from Wimbledon School of Art in July 2004.

Left: Matt Collier
Post Selection Translation, 2005.
Installation at South
Wimbledon station.
Image courtesy the artists and
London Underground.
Photo: Daisy Hutchison.

Right: Feltham Young
Offenders' Institute,
Southwark Mural, 2004.
Installation at Southwark station.
Image courtesy the artists
and London Underground.

60 inmates from the Feltham Young Offenders' Institute created a seven metre long mural at Southwark station.

The 15 to 18 year olds depicted a map of London, including geographical features and well-known landmarks, giving themselves a rare opportunity to express themselves, display their talents and challenge people's stereotypes about young offenders.

The project was developed to encourage talented young men to pursue artistic careers. Prison is a very inward looking world, separate from society. Projects such as this help build positive links with the community and give something back. The artworks as a vehicle to build self-esteem and communications skills. This project has given young people at Feltham an opportunity to have their artwork seen and recognised by a greater audience.

London College of Communication/University of Arts/ Underground Staff/26/Cyan Books
From Here to Here

Circle line
September – October 2005

Taking inspiration from the locations, history and architecture of the 27 Circle line stations and part of the London Design Festival, *From Here to Here* was a collaboration between Platform for Art, London Underground staff, design students from London College of Communication, and the writers' group '26'.

The locations, history and architecture of the 27 stations of the Circle line inspired 27 posters displayed across the Underground system and 27 stories, recounted by members of London Underground staff, writers from '26' and students from London College of Communication and was produced in a book published by Cyan Books.

Simon Jones, Clive Norman, Jessica Chamberlain, Louise Lee, Yuki Komatsu, Kai Fai Sui, Brian Richards, Chris Shelton, Stephen Markey, *House is where the home is: exploring the intimate nature of the House that feels like a home*, 2006.
Mansion House station.
Image courtesy the artists.

Various Artists
Olympic Draw & Dream

Stratford and Wembley Park stations
June – July 2005

Ed Everett and Julia Parry
Holiday

South Wimbledon
June 2005

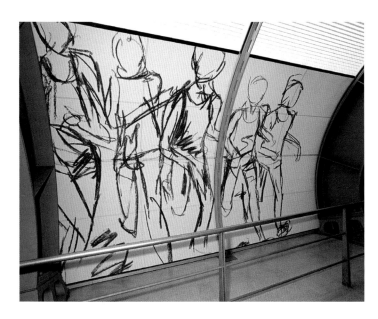

Local school children created giant illustrations to capture the excitement and magic of the Olympic spirit. The large-scale works were presented at Stratford and Wembley Park Tube stations as part of the Back the Bid campaign supporting London's 2012 Olympic Bid.

Stratford station featured a display of black and white drawings spanning 28 metres in length. The project combined the work of students from ten Newham Secondary Schools and was, coordinated by Newham Council in conjunction with the Royal Academy of Arts.

Ed Everett and Julia Parry collaborated to make a work that explored a dialogue between themselves and their paintings. Using photographs and found images they used a range of collage and image manipulation techniques to create a fictional landscape to be presented in the station. The landscape made reference to a range of international holiday destinations, raising questions around the notion of travelling for leisure.

Various Newham schools,
Olympic Draw, 2005.
Installation at Stratford sration.
Photo: Joshua Millais.

Anthony Luvera
Stories from Gilded Pavements

Posters across the network
January – March 2005

Anthony Luvera worked with homeless and ex-homeless people to capture images that represent their worlds, in an effort to dispel the representation of homeless people as "hobos, beggars and tramps". Luvera flipped the traditional photographer/subject relationship by offering the project's participants their own camera shutter as the creative means to tell their own incredible stories. The resulting images: haunting images of graveyards and dark alleyways combined with inspiring silver-lined clouds on a sunny London day, and strong self-portraits, made for a striking collection that portrayed the lives of London's homeless communities as we've never seen before.

Supported by Kodak, Crisis, the UK's national charity for homeless people, and The Pro Centre, this still-image documentary hinged on weekly photography workshops across London for homeless and ex-homeless people.

Participants were encouraged to look at themselves differently as they were guided through photography skills, the building of portfolios and the creation of Assisted Self-Portraits. The aim of the workshops was to empower participants and help grow their self-confidence. Some 200 homeless and ex-homeless people participated, but many drifted in and out of the project, some with no trace.

Pawel Grygro in collaboration with Anthony Luvera.
Image for poster for London Underground, 2005.
Image courtesy the artists.

Rose Butler with Aldgate East Underground station staff
Platform Portraits

Aldgate East Station
September 2004

Said Otmani,
Plaform Portraits, 2004.
Image courtesy the artist.

This project was a collaboration with Whitechapel Gallery to create photographic self-portraits of London Underground staff. The photographs captured the ideas and feelings the staff have about their daily lives and their work on the Underground.

The staff were inspired by a visit to *Atlas*, an exhibition of work by Gerhard Richter at the Gallery, and responded to his vast work of famous historical and artistic figures, *48 Portraits*. They worked in their own time with the Whitechapel's Education team and the photographer Rose Butler to develop their own photographic portraits which were displayed on the platforms of Aldgate East Underground station. The images celebrate the diversity of London Underground staff while encouraging passengers to see them as individuals and not just 'a uniform'.

ACKNOWLEDGEMENTS

Acknowledgements

BOOK

We wish to acknowledge all those involved in the development and production of this book, especially the main working group in the Platform for Art team who have been responsible for collating all materials and working with the publisher Black Dog Publishing Limited, London, UK.

Thanks are also due to Alex Coles for so enthusiastically taking up the challenge to bring his external perspective to the programme through his essay.

PROGRAMME

This is a much needed opportunity to acknowledge and thank all those that have been involved in the programme. Platform for Art has achieved a great deal in a relatively short time. From its beginnings at Gloucester Road station the programme has been growing to include many sites around the Tube network and the pace is set to continue over the next few years. The task of thanking all those individuals who have played their part in this development and in the delivery of a huge number of projects is enormous. Our apologies to all those whose names may have been accidentally omitted but huge thanks to all that have worked with us and who continue to do so.

ARTISTS

First of all we would like to thank all the artists that we have had the privilege to work with and who have produced an astonishing range of work as part of the programme:

Faisal Abdu'allah, Eleonora Aguiari, Isabel Albiol Estrada, Louise Aldophsen, Asia Alfasi, Zoe Anderson, Axel Antas, Chiho Aoshima, Lars Arrhenius, Jonathan Ashworth, Peggy Atherton, Raul Ortega Ayala, Charlie Baird, Zhao Bandi, Fiona Banner, Guy Bar Amotz, Ruth Barker, Martin Barron, David Batchelor, Paul Bawden, Simon Bedwell, Phil Beeken, David Begbie, Ioannis Belimpasakis, Divyesh Bhanderi, Sigga Bjorg Sigurdardottir, Quentin Blake, Rut Blees Luxemberg, Simon Bloor, Tom Bloor, Anna Boggon, Adam Bridgland, Sarah Bridgland, Mel Brimfield, Sarah Brittain Edwards, Julio Brujis, Jo Bruton, Janet Burchell, Rose Butler, Paul Catherall, Glauce Cerveira, Jacqui Chanarin, Sula Chance, Gayle Chong Kwan, Ed Clark, John Cooper Clarke, Giulietta Coates, Hen Coleman, Sarah Coleman, Matt Collier, Sarah Colman, Roz Cran, Kate Davies, Siobhan Davies, Panagiotis Davios, Shezad Dawood, Corrine Day, Mark Dean, Jeremy Deller, Karen Densham, Beth Derbyshire, Poulomi Desai, Othello De'Souza Hartley Suki Dhanda, Rachael Dickson, Beatrice Dillon, Braco Dimitrijević, Mark Dion, Marysa Dowling, John Dunbar, Stephen Duncan, Isobel Dunhill, Elizabeth Eamer, Amy Ella, David Evans, Ed Everett, John

Farnham, Fengyan, Duggie Fields, Graham Findlay, Doug Fishbone, Bill Fontana, Samuel Fosso, Mary Anne Francis, Irene Frohlich-Weiner, Miss FX, Mathieu Gallois, Phil Garrett, Kendell Geers, Ella Gibbs, Sara Gilbert, Liam Gillick, Sophie Goldthorpe, Milena Goodman, Lothar Götz, Brian Griffiths, Anthony Gross, GT, Colin Guillemet, Guo Hang, Jitka Hanzlova, Michael Hardy, Ellie Harrison, Aileen Harvey, Kendra Haste, Xian He, Fiona Hepburn, Barney Heywood, Damien Hirst, Tessanna Hoare, Pam Hogg, Dan Holdsworth, Mark Hosking, Aiden Hughes, Gary Hume, Abigail Hunt, Jim Isermann, Emma Jamieson, Andrea Jespersen, Dick Jewell, Fang Jia, Lucy Jones, John Chris Jones, Barry Kamen, Emma Kay, Simon Keenleyside, Maisie Kendall, Rick Kikrby, Tarka Kings, Chila Kumari Burman, Antii Kytönen, Fabrice Lachant, Natasha Laflin, Chris Landoni, Liane Lang, Andy Lawson, Rama Lee, Mandy Lee Jandrell, Tom Leighton, Simon Linke, Ren Liu, Peter Lloyd, Eleanor Long, Annie Lovejoy, Rosa Loy, Anthony Luvera, Lylinlin, Hanan Magou, Scott McFarland, Gordon McHarg, Grace McMurray, Mekons, Debbie Metherall, Beatriz Milhazes, Jane Miller, Heather & Ivan Morison, Catherine Morland, Sarah Morris, Motiroti, Victor Mount, Muntean/Rosenblum, Grace Murray, Triochard Muyiwa, Heena Nadeem, Yoshitomo Nara, Courttia Newland, Richard Niman, Joanne Noble, Nils Norman, Sally O'Reilly, Rob Olins, Dick Onians, Yoko Ono, Gabriel Orozco,

Tony Oursler, Xian Pang, Janette Parris, Julia Parry, Raksha Patel, Eileen Perrier, Shyama Persaud, Vinca Peterson, Bill Phelps, Paola Pivi, Amy Plant, Guy Portelli, Sarah Poynter, Priten Patel, Marc Quinn, Ben Ravenscroft, Jamie Reid, Zhandra Rhodes, Sophy Rickett, Ugo Rondinone, Robert Rush, Joe Rush, Emma Rushton, Paul Ryan, Tajender Sagoo, Tracey Sanderswood, Zineb Sedira, Colin Self, Nigel Shafran, Shengjie, Allison Sherburne, Cindy Sherman, Shez360, Yinka Shonibare, David Shrigley, John Simmons, Paul Simonon, Lucy Skaer, Gerry Smith, Bob and Roberta Smith, John Speilman, John Spencer, Georgina Starr, Carl Stevenson, Gemma Stokes, Nina Sverdvik, Akiko Takizawa, Fiona Tan, Sinta Tantra, Wang Tao, Yiqian Tao, Yoshitomo Tara, Robin Tarbet, Juergen Teller, Matthew Tickle, Mark Titchner, Ruth Todhunter, Alessandra Travagliati, Gavin Turk, Clare Twomey, Derek Tyman, James Unsworth, Sylvie Vanenhoucke, Maria Vlotides, Martina Volfikova, Jessica Voorsanger, Naglaa Walker, Christian Ward, Louise Watson, Richard Wentworth, Vivienne Westwood, John Williams, Stephen Willats, Jane Wilson, Keith Wilson, Louise Wilson, Richard Woods, Amy Woolley, Tomoko Yamaguchi, Chen Yang, Lynette Yiadom-Boakye, Zhangtie.

THE CURRENT PLATFORM FOR ART TEAM

Tamsin Dillon – Head of Platform for Art
Sally Shaw – Curator
Anya Oliver – Technical project manager
Cathy Woolley – Community projects producer
Tasha Cummings – Admin coordination

PLATFORM FOR ART ADVISORY PANEL

Current

Tim O'Toole – Chair, Judith Nesbitt, Justine Simons, Keith Khan, Caro Howells, Mark Titchner, Richard Parry, Liz Norris, Chris McLeod, Anna Vickery.

Previous members

Richard Wilkinson, Gavin Turk, Chris Townsend, Jemima Montagu.

FORMER MEMBERS OF THE PLATFORM FOR ART TEAM INCLUDE:

Liz O'sullivan – Head of Platform for Art until mid 2005 who led the way in establishing the programme and building advocacy and support for it within the organisation to ensure its establishment as an integral part of London Underground.
Tamsin Dillon – Curator 2002–2005
Catherine Gibson – Curator 2005–2006
Victoria Jones, Sara Ellen Williams – Community Projects Coordinators
David Gleeson – Press
Jason Newton, Louise Ward – Project Managers
Anne Coffey, Rachel Cole, Natasha Jacoby, Lisa Sanguedolce, Eliza Patten, Rachel Kent, Nadia Damon – Admin Coordinators
Jim Drennan, Sarah Collinson, Chris Steele, Lisa Ewer, Peter Hoggard, Iain Sutherland – Technical Project Managers
Sarah Davies, Anna Simson, Emma Mandley – Strategy Consultants
Milena Malovic, Katie Day, David Bowen, Lisa Ewer, Alan Jones – Programme Assistants

The following people also played a key role as Platform for Art got under way; they believed in the need for the programme and that it would succeed:

Adam Goulcher, Steve Wright, Richard Smith, Paul Godier, Mike Brown, Sir Malcolm Bates, Paul Amlani Hatcher.

FUNDERS/PROJECT SUPPORT

Arts Council England, Arts and Business, Calouste Gulbenkian Foundation, Becks, Bloomberg.

LONDON UNDERGROUND STAFF AND CONTRACTORS

Platform for Art depends on the support of many London Underground and Transport for London staff as well as contractors who work in design, print, technical fabrication and installation, planning, legal and many other areas in order to realise all projects:

Kim Andersen, Roy Ale, Francesca Alaimo, Mike Ashworth, John Ball, Liz Barrett, Peter Bashford, Mike Baxter, Lisa Belloni, Phil Bird, Shivaunne Booth, Mike Bowler, Doug Brown, Tony Burrows, David Caines, Peter Campbell, Matt Carney, John Carter, Mike Challis, Jason Collins, Jon Cordery, Paul Cully, Tony Darke, Mick Dwyer, Lynne Dyer, Alexandra Ebert, David Ellis, Innes Ferguson, Peter Fiorentini, Kevin Fisher, Sumitra Francis, Marian Forkin, Gilly Fox, Paul Giraud, Stuart Goode, Adam Goulcher, Chrissie Grant, Michael Graves, Katherine Green, Richard Greer, Irene Gross, Penny Hazell, Jon Helm, Keith Henderson, Dave Hirst, John Hough, Nat Hunter, Peter Jukes, Tony Kidby, David Leboff, Steve Lewis, David Monson, Fraser Muggeridge, Louise Newlands, Chris Ntende, Chris Nix, Chris Oduola, Jan O'Neil, Soyer Osman, Said Otmani, Joe Paterson, Mark Purkis, Michael Riley, Andrew Rolph, Terry Roth, Mary Rushton-Beales, Chris Shew, Theresa Simon, Neil Skelton, Mike Smith, Albanne Spyrou, Allan Stanley, Lindsey Stringer, Andrew Terry, Peter Tollington, Nick Triviais, John Vallance, Dave Vickers, Michael Walton, Jon Wearne, Russell Weighton, Richard and Robert Wheal, Michelle Williams, Lucy Wilson, David Young.

PROJECT PARTNERS

Collaboration and working in partnership plays a huge role in the programme and we would like to thank all those organisations that have played a part in the projects we have produced together:

Galleries, Museums and arts organisations

Art for Offices, Arts & Kids, Aspex Gallery Portsmouth, Autograph, BBC London, Bookworks, Bowieart, Camden Arts Centre, Campaign for Drawing, Corvi-Mora, Cow Parade, Create, Danielle Arnaud, Emily Tsingou Gallery, Essor, Laurent Delaye Gallery, Design Museum, East London Dance, Exhibition Road Cultural Group, FA Projects, Stephen Friedman Gallery, Fashion & Textiles Museum, Frieze Art Fair, Frieze Projects, Frith Street Gallery, Fovea Gallery, Greenwhich and Docklands Festival, Hales Gallery, Hayward Gallery, Harrow Museum, Haunch of Venison, ICA, Ikon Gallery Birmingham, Immprint Design, London Design Festival, London Gallery West, London Sinfonietta, London Transport Museum, Manchester Art Gallery, Matts Gallery, MW Projects, Andrew Mummery Gallery, Natural History Museum, October Gallery, One in the Other, Maureen Paley, Peer, Photographer's Gallery, PM Gallery and House, Pump House Gallery, Rhodes + Mann, Royal Academy of Art, Serpentine Gallery, Shanghai Metro, Siobhan Davies Dance Company, South London Gallery, Stockwell Festival, Tate Modern, Tate Britain, Vilma Gold, Whitechapel Art Gallery, Union Projects, Urban Development, Victoria and Albert Museum, Victoria Miro Gallery, Vilma Gold, White Cube, Wysing Arts Centre, 26 Writers group.

Schools and Colleges

Wimbledon College of Art, Allen Edwards Primary School, Barking Abbey School, Carpenter's Primary School, Central Academy of Fine Arts Beijing China, Childeric Primary School, Dagenham Park Community School, Feltham Young Offenders Institute, Geoffrey Chaucer Primary School, Grange Primary School, Kingsbury High School, Kingsley High School, London College of Communication, London College of Fashion, Middle Row Primary School, Nanjing Arts Institute China, Nanjing Normal University China, RNIB Sunshine House School, Royal Academy Schools, Royal College of Art printmaking, Snowfields Primary School, Soho Parish Primary School, Southwark College, St Michael's Catholic School, St. Olave's School, St. Saviour's School, Tower Bridge Primary School, University of Westminster, University of the Arts, Waverley Girls School, Wessex Girl's Youth Group, Wimbledon College of Art.

Other organisations

Arsenal Football Club, Borough Market, Morden Women's Institute, North East London Mental Health Trust, Roast restaurant, Visit London, Stockwell partnership, Candid Arts Trust.

COLOPHON

Designed by Matthew Pull at Black Dog Publishing.

Black Dog Publishing Limited
10A Acton Street
London
WC1X 9NG
United Kingdom

Email: info@blackdogonline.com

www.blackdogonline.com

British Library Cataloguing-in-Publication Data.

A CIP record for this book is available from the British Library.

ISBN: 978 1 906155 06 3

Black Dog Publishing Limited, London, UK, is an environmentally responsible company. *Platform for Art* is printed on Sappi Magno Satin, a chlorine-free, FSC certified paper.

architecture art design
fashion history photography
theory and things

www.blackdogonline.com london uk